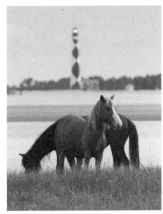

The Wild *Horses*
of Shackleford Banks

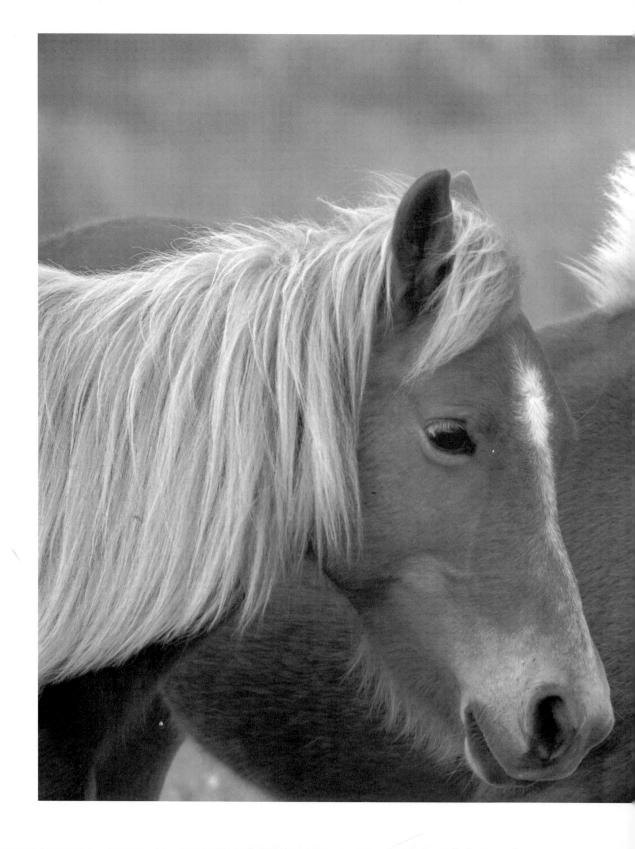

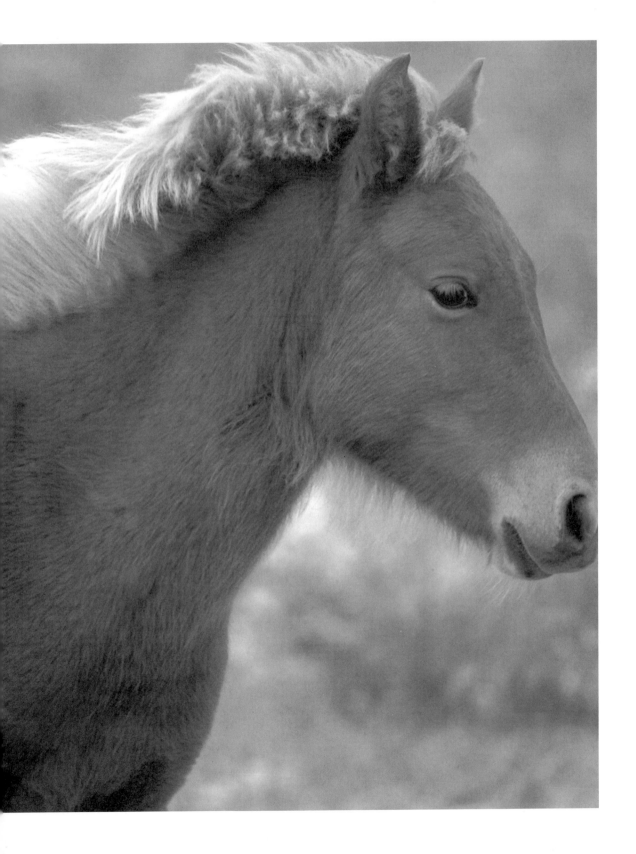

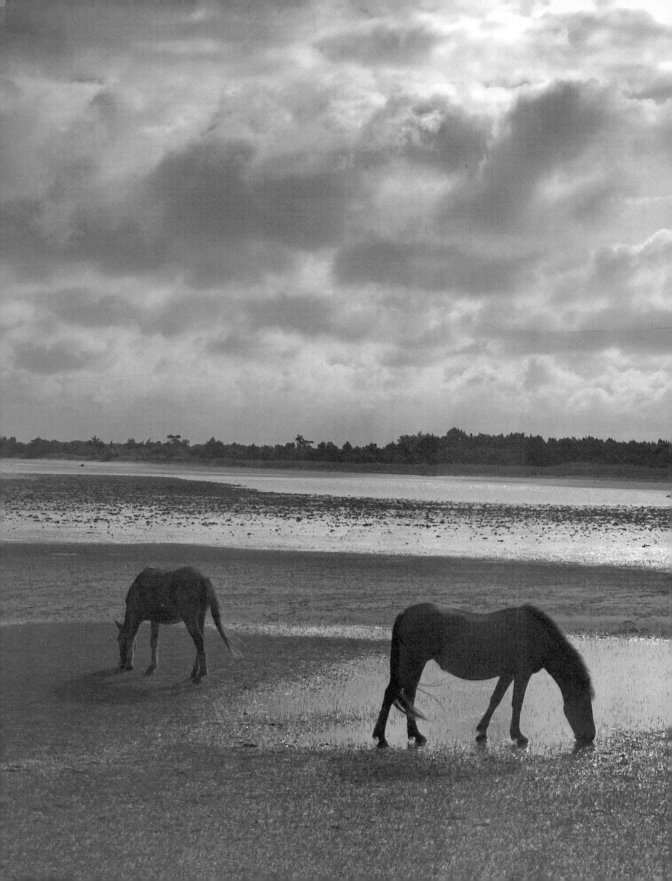

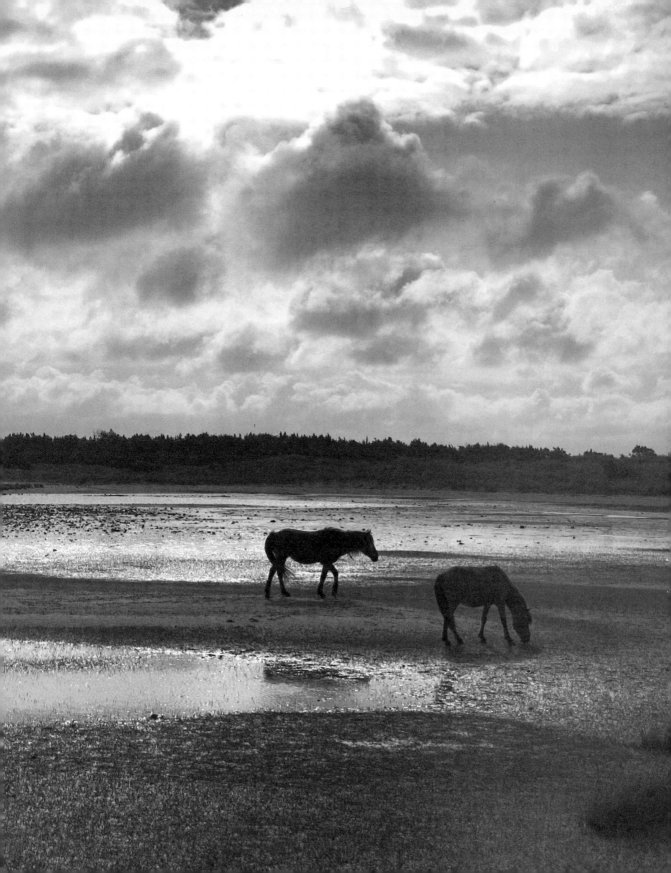

BOOKS BY CARMINE PRIOLI

Lines of Fire: The Poems of Gen. George S. Patton, Jr. (1991)
Hope for a Good Season: The Ca'e Bankers of Harkers Island (1998)
*Life at the Edge of the Sea: Essays on North Carolina's Coast and
 Coastal Culture*, with Candy Beal (2002)

≈≈

BOOKS WITH PHOTOGRAPHS BY SCOTT TAYLOR

Seashells of North Carolina, by Hugh J. Porter and Lynn Houser
 and edited by Jeannie Faris Norris (1999)
Coastal Waters: Images of North Carolina, by Scott Taylor (2000)
Song of an Unsung Place: Living Traditions by the Pamlico Sound,
 by Bill Mansfield (2001)
Mariner's Menu: 30 Years of Fresh Seafood Ideas, by Joyce Taylor (2003)

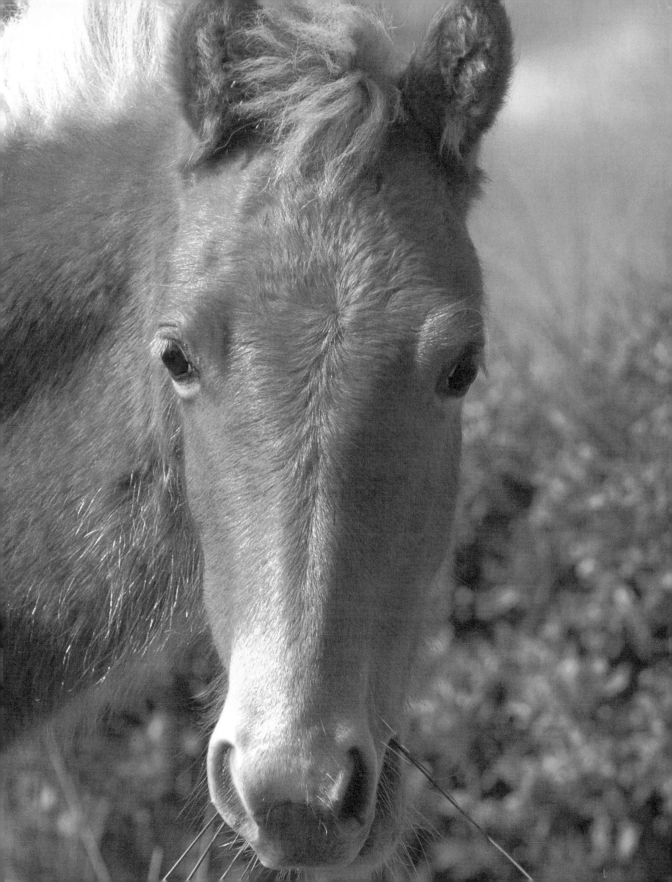

JOHN F.
BLAIR
PUBLISHER WINSTON-SALEM, NORTH CAROLINA

The Wild Horses of Shackleford Banks

Text by Carmine Prioli

Photographs by Scott Taylor

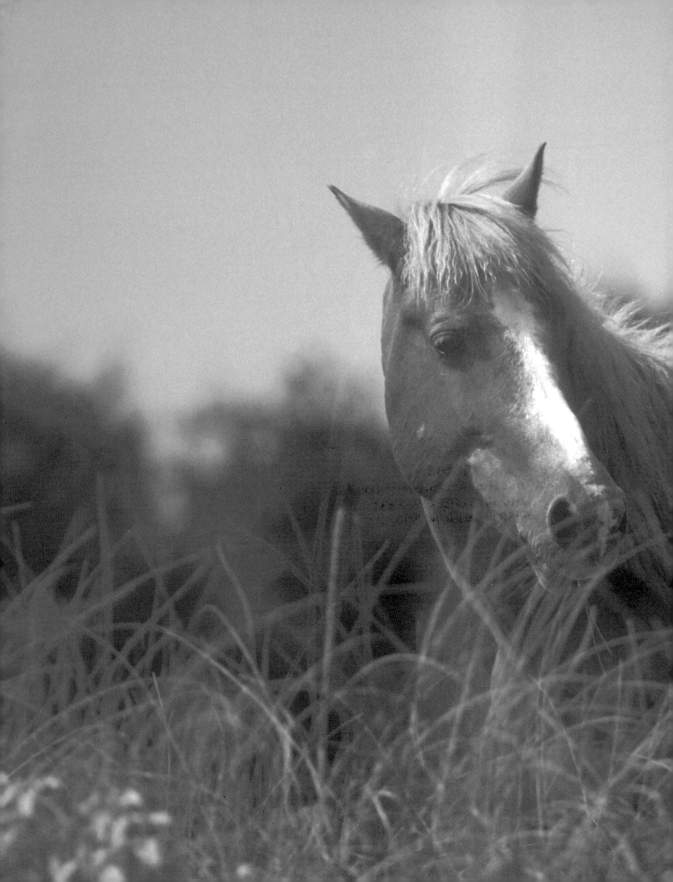

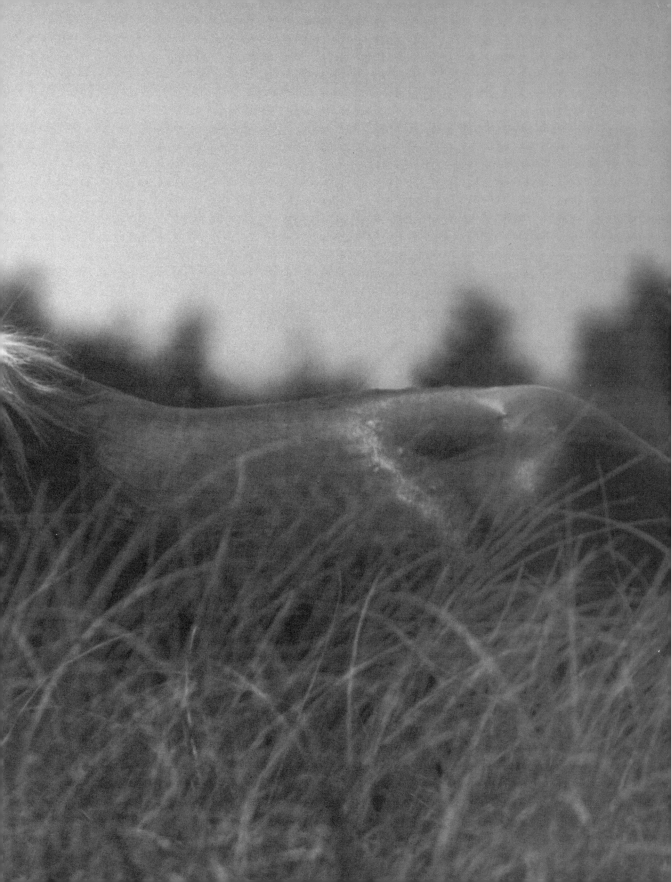

PRINTED IN CANADA

The paper in this book meets the guidelines for permanence and durability
of the Committee on Production Guidelines for Book Longevity
of the Council on Library Resources.

UNLESS OTHERWISE NOTED, ALL PHOTOGRAPHS IN THIS BOOK ARE BY SCOTT TAYLOR.

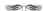

A portion of the proceeds from The Wild Horses of Shackleford Banks
will be contributed to the Foundation for Shackleford Horses, Inc.

Library of Congress Cataloging-in-Publication Data
Prioli, Carmine.
The wild horses of Shackleford Banks / by Carmine Prioli and Scott Taylor.
p. cm.
Includes bibliographical references and index.
ISBN-13: 978-0-89587-334-7 (alk. paper)
ISBN-10: 0-89587-334-6
1. Wild horses—North Carolina—Shackleford Banks. 2. Wild horses—Ecology—North Carolina—
Shackleford Banks. I. Taylor, Scott (Scott David) II. Title.
SF360.3.U6P75 2007
599.665'509756197—dc22 2006027513

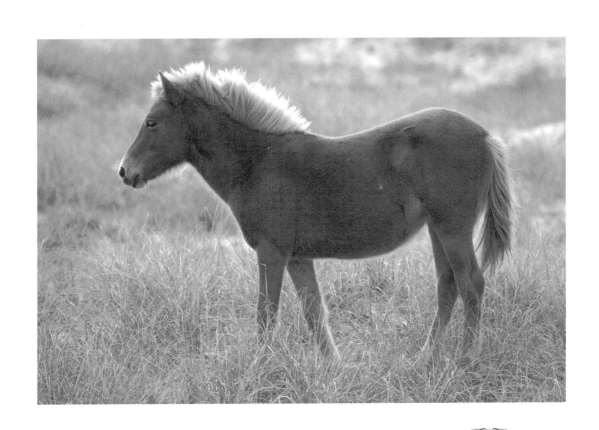

For Elizabeth

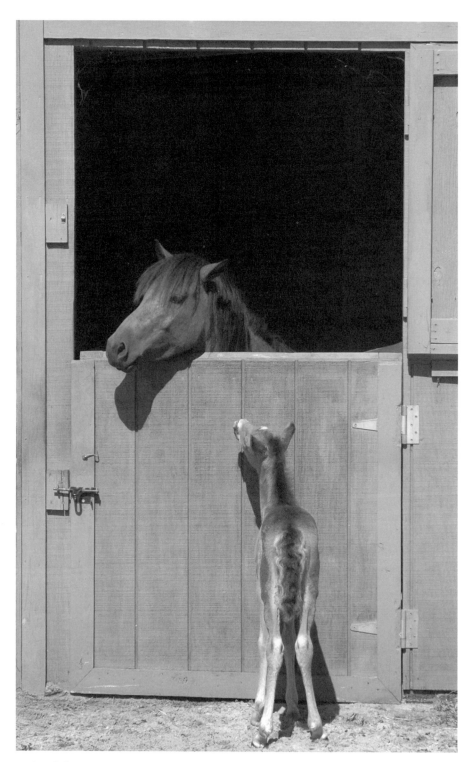

Sophia (left) *and Diego, 2004*

Heloise

Contents

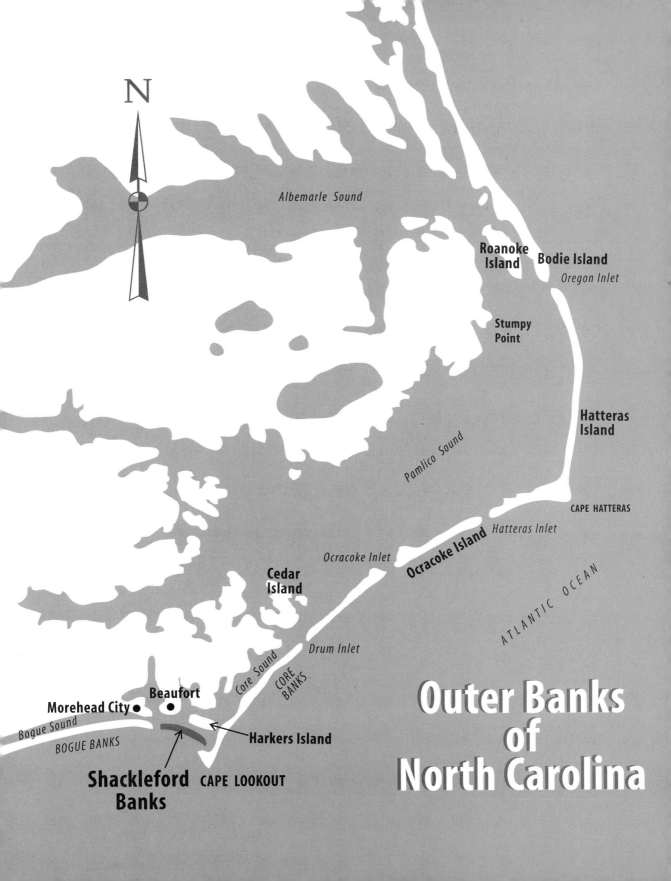

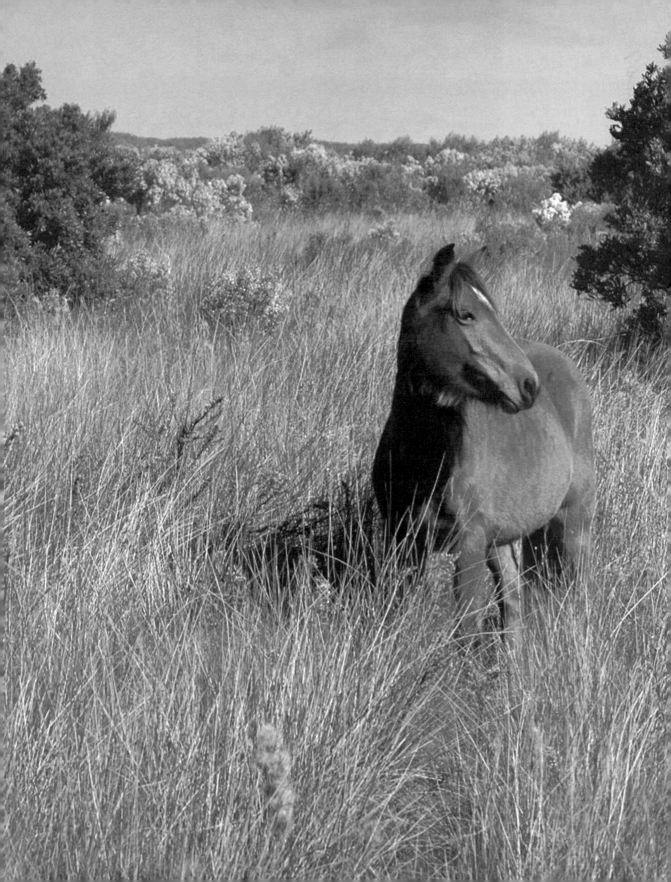

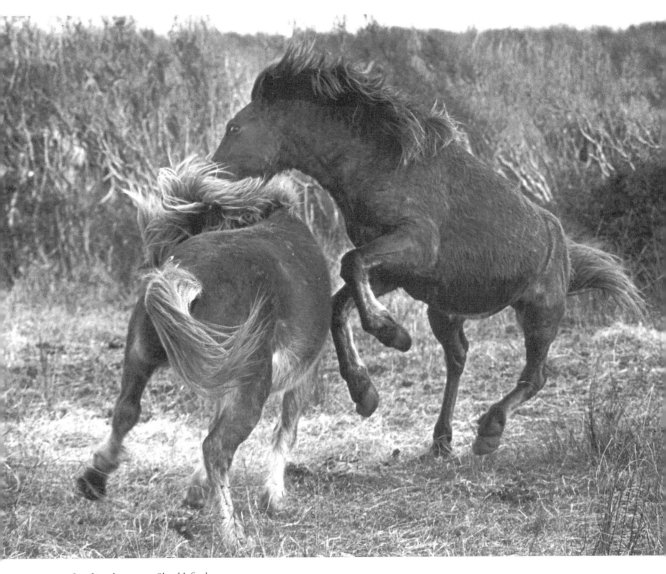

Battling horses on Shackleford

"Life consists with Wildness. The most alive is the wildest. Not yet subdued to man, its presence refreshes him."

Henry David Thoreau, "Walking" (1862)

Horse on Shackleford with live oaks

"No one, except Marilyn, expected MissIsabel."

ASSOCIATED PRESS, OCTOBER 2, 2003

On September 6, 2003, at the height of hurricane season, meteorologists detected a tropical disturbance in the central Atlantic. Within days, the disturbance grew to a depression, then to a storm of epic size, the first category five to develop in open water since Hurricane Mitch in 1995. Winds peaked at 160 miles per hour. Storm clouds roiled above 275,000 square miles of seething chaos, an area bigger than the state of Texas. Named Isabel, the hurricane was one of the strongest to menace the East Coast of the United States in recent times. Moving west-northwest, Isabel swelled, then degraded. During the next few days, the storm was demoted to categories four, three, then two. But Isabel was a "strong" category two, and she stayed on course toward North Carolina's Outer Banks.

Over the years, residents of Carteret County, North Carolina, have become familiar with ferocious storms. Destruction and death were visited upon them by the monster hurricanes of the 19th century, especially the San Ciriaco storm of 1899, which drove scores of ancestral Ca'e Banker families from their Shackleford Banks villages to more secure homes on the mainland.[1] There are descendants of Bankers who still recall the "storm of '33," which opened an inlet west of the diamond-patterned Cape Lookout Lighthouse, severing Shackleford from the elbow at the cape. Many others own vivid memories and worn snapshots of the aftermaths of Hurricanes Carol, Hazel, Donna, and others from the 1950s and 1960s and more recent heavyweights like Hugo, Fran, and Floyd from the 1980s and 1990s. The toll these storms have taken in human life and property damage is beyond reckoning. Animal populations have suffered as well.

Prior to the 1930s, when they were removed to preserve the islands' vegetation and, later, to make way for land development, free-roaming livestock—cattle, sheep, goats, pigs,

and horses—were common everywhere on the Outer Banks.[2] When the big storms arrived, these animals stood unshielded against tempests and tidal surges. Thousands perished in what older Bankers called "sheep storms."[3] Their drowned carcasses washed up on the mainland shoreline, often many miles away.

Domestic livestock and wild horses were not removed from Core Banks and Shackleford Banks until the 1950s, when, bowing to the march of progress, the North Carolina General Assembly ordered their removal. Swayed by emotional pleas from a group of Harkers Island residents, Tar Heel legislators allowed an exception for the wild horses of Shackleford Banks. (An exception was also granted on Ocracoke Island, where the nation's only troop of mounted Boy Scouts captured, tamed, and rode wild Banker horses.)[4] The Shackleford horses are revered in Carteret County today, just as they were in the 1950s. And when Hurricane Isabel was wheeling toward North Carolina, nearly everybody was worried about them.

Isabel was the largest hurricane to hit the North Carolina coast since Floyd had pitched ashore almost exactly four years earlier, on September 16, 1999. Floyd was also a strong category two, and coastal-plain residents remember it well. That storm cost at least $6 billion in damages and killed 52 people in eastern North Carolina alone.

Isabel had the potential to release wave and wind energy of similar proportions. Predictions called for sustained winds approaching 105 miles per hour, gusting to 115; a storm surge of seven to 11 feet above normal tide levels; isolated tornadoes; and total rainfall of six to 10 inches. Two days before Isabel's anticipated landfall, North Carolina officials ordered 921 Ocracoke Island residents to the mainland. Farther north in Norfolk, Virginia, the navy sailed 40 of its ships out to sea for protection. The air force flew 170 aircraft inland, retreating from coastal bases. States of emergency were announced from North Carolina to Pennsylvania. Amtrak canceled rail service south of Washington, D.C. Air-traffic controllers grounded 5,700 flights at 20 East Coast airports. For the first time due to the threat of a hurricane, government offices were closed in the nation's capital.[5]

Hurricane Isabel made landfall near Drum Inlet at 1:00 P.M. on Thursday, September 18, 2003. Although sustained winds and tidal storm surge were less than predicted, the storm's overall impact was enormous. Officials estimated the destruction in seven states at $3.37 billion. Fifty-one people died. In North Carolina, property damage totaled $55 million, and three people drowned. President George W. Bush declared North Carolina and Virginia disaster areas.

The North Carolina coast was punished severely and altered geographically. Just off the Outer Banks at 2:11 P.M. on September 18, the army's Coastal Hydraulics Laboratory detected the largest wave in the lab's 27-year history. Cresting at 39.7 feet, it was one of several colossal waves between 36 and 40 feet timed in less than an hour by one of the lab's wave-rider buoys two miles offshore. On Hatteras Island, the storm tore open a gash nearly 500 feet wide with three channels, creating the first new inlet between Pamlico Sound and the Atlantic Ocean in 40 years.[6]

Shackleford Banks is the southern terminus of Cape Lookout National Seashore, a rare 56-mile sweep of undeveloped Atlantic shoreline. Unlike Portsmouth Island and Core Banks, which make up the rest of the seashore and have a generally north-south orientation, Shackleford runs roughly east-west. This means that the island, which is nine miles long and averages a half-mile in width, is exposed to the region's prevailing southwest winds. Over the millennia, these winds have helped maintain the island's primary and secondary dunes. Some of the dunes are 35 feet high and provide the natural barrier necessary for creating a maritime forest. The salt spray that the winds carry over the dunes shapes the wedge-like crowns of the live oaks of the island's interior woodlands.

Shackleford's east-west orientation also gives the island cover from some of the most destructive hurricane winds, at least those powered by storms steering a northwest course. Since hurricanes in the Northern Hemisphere rotate counter-clockwise, it is Core Banks in Carteret County that takes northeast assaults broadside. Shackleford is more securely positioned, behind the natural breastwork of Core Banks and Cape Lookout.

These conditions, the island's relatively high ground, and its maritime forest made it suitable for year-round human habitation. In the 19th century, the island was home to several fishing and whaling communities, including the fabled Diamond City, which had about 500 residents. Although those Bankers harvested their livelihoods primarily from the sea and sounds, they also grew peach and fig trees in the lee of the high dunes and woodlands. Adjacent to their homes, they cultivated small gardens.[7] Those gardens and the Bankers' cottages were enclosed by fences to keep out foraging livestock and wild horses.

There is no record of how many horses lived on Shackleford in the 19th century. Until the hurricane of 1933, the island was connected to Core Banks. It is known that thousands of horses roamed the entire length of the Outer Banks from Beaufort Inlet north to the Chesapeake Bay until well into the 20th century. On Shackleford, the topography that at one time made the island suitable for human habitation also made it ideal for horses. Thanks to its high ground and protection from gale winds, Shackleford offered an abundance of *Spartina alterniflora* (a dune grass) and sea oats for grazing. Freshwater pools were on the surface or were accessible by digging a foot or two below the sand. The dense maritime forest on the sound side of Shackleford provided live oaks and cedars for whaleboat frames and planking. Tightly woven thickets of myrtle and cedar also covered the sound-side portions of the island.[8] Many generations of Shackleford horses have learned to use the maritime forest and thickets to their great advantage, especially for riding out storms.

Today, Shackleford's woodland stretches intermittently over about 3.3 miles of the midwest portion of the island and runs one mile north and south at its widest point. John Alexander and James Lazell describe this relict of ancient maritime forest as "both an island and an anchor in the ecology of the Outer Banks." Less than 2,000 years old, Shackleford's forest is the youngest of three

important maritime forests on the Outer Banks. (The other two are Buxton Woods on Hatteras Island and, farther north, Nags Head Woods on Bodie Island.) Records indicate that 200 years ago, Shackleford's loblolly pines and live oaks shaded the island all the way to Cape Lookout.[9] While some of the forest was lost as a consequence of livestock—particularly goats and sheep[10]—grazing at its outer edge, much more vegetation succumbed to storms and the harvesting of the woodland's timber for home and boat construction. The removal of salt-tolerant live oak trees resulted in the loss of the thick canopy that protected salt-sensitive species of trees and bushes.

The forest has rebounded in the two decades since Shackleford's livestock was removed in 1985. Horses tend to consume other forms of vegetation. Cavernous and impenetrable except for a meandering network of horse trails, some just waist-high, the forest is a hinterland of almost gothic serenity.

In the aftermath of Hurricane Isabel, Down East residents were relieved that the worst predictions had not come to pass, but no one knew the fate of Shackleford's 124 horses. That responsibility fell upon the two organizations charged by federal mandate with implementing horse management on Shackleford—the National Park Service and the Foundation for Shackleford Horses, Inc. For several days following the storm, foundation directors Susan Willis, Rose Griffin, and Carolyn Mason and Park Ranger Sue Stuska scoured the island counting noses and checking off names from printed horse-population lists. They were resolved to locate—or account for—the entire herd.

The bodies of five horses that washed up on Harkers Island were identified as natives of the Rachel Carson Estuarine Reserve near Beaufort. They were not from Shackleford. In the absence of additional reports of dead horses, there was reason to be guardedly optimistic. The best anyone hoped for was that all of Shackleford's horses would somehow have survived the storm. No one expected to see *more* horses on the island than the 124 that lived there before Hurricane Isabel. But nature on the Outer Banks writes her own script, and that's precisely what happened. Three horses in good condition—a colt, Sugarfoot, and two adult mares, Joanne and Zap—were swept from the Rachel Carson Estuarine Reserve. Unlike their five less-fortunate companions that drowned in Isabel's floodwaters, these three were carried one mile across Back Sound until they gained footing somewhere on the northern side of Shackleford. After Hurricane Isabel, Sue Stuska was the first to discover them. "We can't be sure exactly where they landed," she recalls. "But I found them on the northwest edge of Shackleford—as close as possible to their home."[11] Since these three castaways were not members of the Shackleford herd, whose identities and numbers are meticulously controlled, they were tested for (and cleared of) diseases in early October, then tranquilized, loaded on boats, and returned to their original island range on the preserve.

However, there was also a *fourth* new horse on Shackleford—a filly not more than 48 hours old when she was first sighted on September 22, 2003. Although she was not counted among the 124 residents of the island

MissIsabel when first sighted shortly after birth with Marilyn
COURTESY OF CAPE LOOKOUT NATIONAL SEASHORE, 2003

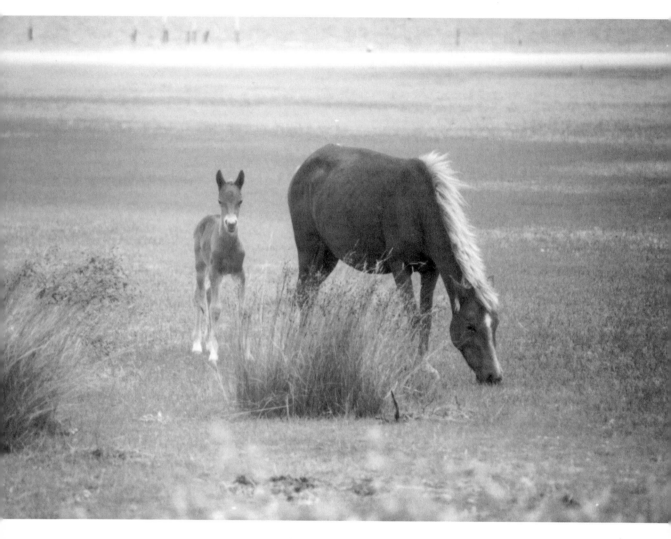

MissIsabel at six days old with Marilyn

before the storm, she was very much a member of the island's horse family, clinging to her mother, a nine-year-old Shackleford mare named Marilyn. No one in the park service or the foundation knew that Marilyn was pregnant, and September is late for horses to give birth. Nor could anyone firmly establish where or when Marilyn had gone into labor, though it was probably about two days after Isabel's storm clouds and winds barreled off to the northeast. But wherever and whenever she had come into the world, Marilyn's baby needed a name.

For 25 years, Princeton University behavioral ecologist Dan Rubenstein and his students have been studying the horses of Shackleford Banks. To assist them in identifying horses, they use a naming scheme whereby foals receive names beginning with the first letter of their mother's name. Because this system sim-plifies efforts to identify horses of the same matrilineage, both the park service and the foundation have adopted it. But since Isabel was the obvious name for Marilyn's hurricane filly, they had a problem. A quick-thinking volunteer offered the perfect solution. Why not simply call her Miss Isabel and combine the two words? The proposal was unanimously accepted, and the new filly was christened MissIsabel. She came into the world as a surprise. "No one, except Marilyn, expected MissIsabel," reported the Associated Press. She immediately became a celebrity, an adorable brown-eyed embodiment of the spirit of her ancestors, the wild horses that have lived by the edge of the sea—and beaten the odds—for more than 350 years.

≫≪

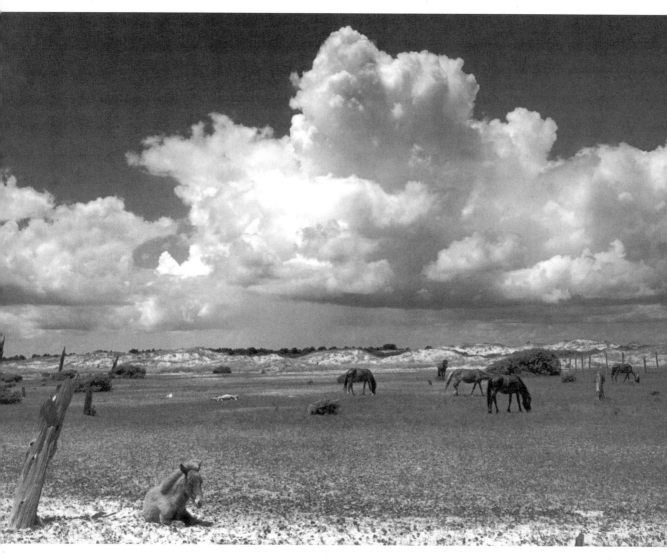

Horses on Shackleford amid remnants of the ancient maritime forest that once blanketed the island

It is an article of faith among many residents of Carteret County that MissIsabel and the entire Shackleford herd are wild ponies whose ancestors were the proud mounts of the Conquistadors. Local tour-boat skippers rarely neglect to inform their passengers that those 16th-century horses first came to the Outer Banks by swimming ashore from wrecked or foundering treasure ships.

That image—or at least the Spanish connection—has persisted for many years, and it had a predictable effect on Discovery Channel filmmakers when they arrived in North Carolina in 1985 to document the scientific work of Professor Dan Rubenstein. The temptation to liven up equine behavioral science with romance and folklore for a national audience was irresistible. Movie star Peter Graves narrated the film before a wind-swept backdrop of grazing harems, battling stallions, sun-drenched dunes, and rolling breakers. Graves referred to Shackleford's horses by name, as if he knew them personally. "The ancestors of Jennifer,

Jupiter, and the rest were war horses," he confidently declared. Those horses had traveled to the New World in the most unpleasant way, "cradled in the holds of Spanish galleons."[1] Because their arrival predated English settlement of the Outer Banks, the horses are therefore seen as the oldest living connection to our colonial legacy. Like their wild mustang cousins out west, the Shackleford horses are noble icons of bedrock American values—independence, self-reliance, freedom.

Other views—mostly those of non-locals or newcomers to the region—tend to be less patriotic and not at all romantic. They contend that Shackleford's horses are not truly wild and that they aren't Spanish either. If they have any colonial origin at all, the horses are the offspring of domesticated animals that came in the 1600s with English-speaking settlers from Tidewater Virginia. Those adventurous souls acquired their livestock from English breeders, whose horses contained little, if any, Spanish blood. As an "exotic" or non-native

species, the descendants of *those* animals have no business grazing at will on Shackleford, one of the few remaining wilderness areas in the American Southeast. Like the cattle, sheep, and goats that used to be their island companions, the Shackleford horses—say the critics—should also be removed.

At one time, there were heated and very public arguments over whether or not the horses had any right to remain on Shackleford Banks, and if so, how many should be there and how and by whom they should be managed. Although that debate is now mostly settled, issues related to the Shackleford horses can still generate impassioned discussion. Leaving aside for now the issue of Spanish ancestry, it's possible to address a pair of questions without risking too much of a stir. Are the members of the Shackleford herd ponies or horses? And are they truly wild? Simple questions. But in the matter of wild horses, simple questions rarely yield simple answers.

It is obvious to any observer that Shackleford's horses are smaller than most domesticated horses, but they are ponies only in the loosest definition of the term. Ponies are specific animals, like the Shetland and Welsh breeds, which grow only to 14.2 hands, or about 56 inches from the ground to the withers. (A hand, a unit of measurement dating to medieval times, equals four inches, or about 10 centimeters. Medieval war horses measured about 16 hands. A horse's withers is the high point where neck and back join.) Although the Shackleford horses are small—some say "stunted"—and typically average 12 hands[2] in the wild, their size is a consequence of their diet of *Spartina*, which com-

prises about 50 percent of their nutriment. Young Shackleford horses living on the mainland as domesticated pets eat more balanced diets and are robust and full bodied. They show signs of growing taller than their island counterparts. In May 2005, a foal named Doña was born on the mainland of Shackleford parents also living on the mainland. It will be revealing to observe how tall Doña grows as she is fed manufactured horse feed and as she enjoys the shelter and veterinary care typically afforded domesticated animals. For now, wise folks simply refer to the Shackleford herd as "pony-sized horses."

Are Shackleford's horses truly wild? If we overlook the fact that the herd is one of the most observed, studied, analyzed, and managed animal populations in the world, the answer is yes. On Shackleford, the horses are not fed or groomed by human hands. Nor are they provided water, even in times of drought. They are left entirely alone to mate, to play, to fight, and at times to injure each other. The alpha stallions protect their harems from sexual harassment by roving, curious bachelors. The alpha mares establish and maintain their authority within the harem and settle their own disputes. With the exception of the now-infrequent roundups that maintain the population between 120 and 130 horses, the herd receives no medical attention. With only rare exceptions—rescuing a stranded foal, for instance, or euthanizing a hopelessly injured animal—Shackleford's horses live and die without human interference. On a day-to-day basis, they could not be more wild.

However, there is only one truly wild breed of horses in the world, and it doesn't

live in Carteret County, North Carolina. Known as "Przewalski's horse" for the Russian explorer who was introduced to them on the edge of the Gobi Desert in 1878, they are the only surviving horses descended from non-domesticated animals. Until they were reduced by overhunting, Przewalski's horse—also known as the Asian wild horse—grazed the steppe country of Siberia, Mongolia, and northeast China and were never tamed or crossbred. Today, they have been reduced to a few breeding herds and live, ironically, in zoos in Russia, Europe, and the United States.

The prehistoric ancestors of horses were as free-roaming and untamed as mastodons and saber-toothed tigers. But those wild ancestors mysteriously disappeared some 10,000 years ago, leaving only domesticated horses to carry on the species. Strictly speaking, even "wild" horses grazing and living entirely on their own are actually feral animals.

Of course, none of this information has ever discouraged Down East citizens from calling their beloved Shackleford horses "wild ponies." This unwillingness to alter what is true to their hearts and heritage was a major factor leading to the so-called Shackleford Banks pony war of 1997. That face-off between a grass-roots organization and the United States Department of the Interior resulted in a federal mandate—P.L. 105-229—intended to preserve both the horses and Shackleford. Popularly known as the Shackleford Banks Wild Horses Protection Act, the law in effect legislated the "wildness" of Shackleford's horses. It has also shaped the island's appearance and ecology.

Technology is the handmaiden of this leg-islation. A thicket of acronyms suggests the manner in which wildness—at least on Shackleford Banks—is largely a 21st-century fiction. Terms like EIA (equine infectious anemia, an incurable horse disease), PZP (Porcine Zonae Pellucidae, a birth-control vaccine), and the "Q-ac" variant (a genetic marker identified in DNA analysis by the EBTRL, the Equine Blood Typing Research Laboratory) constitute an obstacle course of information challenging anyone venturing to understand the lives of these animals, their destinies and behavior, and the hazards to their existence.

It is unlikely that the debate over whether or not the horses have colonial Spanish ancestry will be settled anytime soon. Genetic testing and the "Q-ac" marker offer tantalizing evidence of Spanish blood. But it can be said with assurance that, whatever their origin, Shackleford's horses will continue to enthrall local families and schoolchildren, politicians and lawmakers, entrepreneurs and business people, artists and musicians, writers and film-makers, and, of course, tourists. And like MissIsabel, they will continue to teach us about matters much greater than themselves or our-selves—the relationship between creatures and the worlds they inhabit, the ever-growing human hunger for wildness, the changing character of wilderness preservation in the 21st century. Still, the colonial history of these animals is edifying and worthy of reasoned debate. Important, too, is the horses' more recent history, and their continuing influence upon the people who love them.

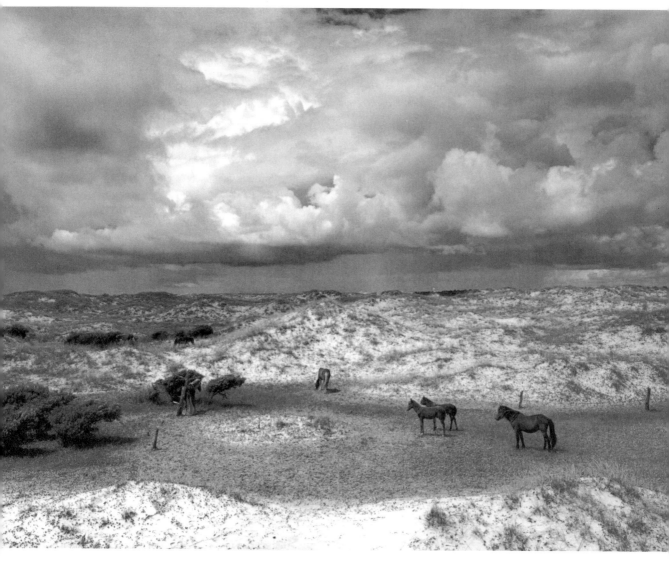

Shackleford Banks interior

The recorded history of horses in the New World begins with the second voyage of Christopher Columbus. It was Columbus who in 1493 brought Spanish horses to Española (Dominican Republic) and began the horse breeding that soon flourished on other islands, including San Juan and Cuba.

The critical early date in the history of New World horses, however, was not 1493. It was April 21, 1519. That day witnessed the arrival at San Juan de Ula (Vera Cruz), New Spain, of 600 armed men and 16 Cuban horses led by Hernán Cortés. Because there were no piers or deepwater ports where his men could hoist and unload their horses, Cortés ordered them pushed overboard. He then jumped into the water himself and swam ashore with his horses.[1] Cortés introduced on the American mainland a lethal combination of steel weapons, firearms, and cavalry that would eventually subjugate the human populations and alter the landscapes of two continents. April 21,

1519, also marked the first time that horses had tried their legs on North American soil in about 10,000 years.

The earliest horses introduced by the Spanish were bred on the Iberian Peninsula. But the bloodlines of those animals coursed far back to eastern Europe, Africa, and Eurasia along an evolutionary stream of 60 million years to the lower Eocene epoch and a creature popularly known as eohippus, "the dawn horse." (Modern paleontologists claim that eohippus is not a valid scientific name and should therefore be neither italicized nor capitalized. The correct term is *Hyracotherium*.) Eohippus was a leaf-eating (herbivorous) animal about the size of a terrier, but thanks to its arched and flexible back, it may have looked more like a combination of a sheep and a jackrabbit than a dog.

While eohippus is known to have lived in Europe, the center of horse evolution was North America, where thousands of eohippus

fossil remains have been uncovered in the American West, particularly the Bighorn Basin in northern Wyoming and the San Juan Basin in northwestern New Mexico. Among horse lovers, eohippus achieved iconic status in 1996 when its image graced a first-class United States postage stamp.

Over a period of millennia in North America and subsequently in Asia, descendants of eohippus developed evolutionary changes. Finally, *Equus caballus*, the so-called true horse, appeared with a single hoofed toe on each foot and a height of about 14 hands (56 inches). Some 25,000 years ago, those animals began migrating northwest and across the Beringia land bridge, which connected what are now Alaska and eastern Siberia. They ranged across the vast Eurasian continent—throughout Russia, the Middle East, western Europe, and northern Africa—where they came into contact with and were domesticated by human populations.

During the periods of horse migration on the American Great Plains, human hunter-gatherers appeared from Asia. These were the so-called Clovis people, named for the shape of their stone projectile points. They traversed Beringia in a southeasterly direction and fanned out across North America. Their primary sources of food were mastodons and other mammals, including horses, that ranged the grasslands and prairies. But before these human populations discovered the horse as a domestic animal, *Equus* (along with a variety of large mammals) mysteriously died out in North America during what paleontologists call "the Great Disappearance."

By the end of the late Pleistocene epoch,

10,000 years ago, horses were extinct in the New World. No one really knows why, though speculation abounds—glaciation during the great Ice Age; the disappearance of prairie grasses or competition for suitable forage from other grazing animals, including bison; overhunting by carnivores, including wolves, saber-toothed cats (which also disappeared), and humans; perhaps an insect-borne epidemic (still a threat to horses today). These and other theories have been proffered, but none has found universal acceptance because supporting evidence is weak or nonexistent.

Whatever caused the extinction of *Equus* in North America, those ancient creatures left behind an ecological niche that their later European-bred descendants readily filled. Since their prehistoric ancestors were biologically nurtured in the environment and climate of North America, the domesticated horses of the Spanish conquest flourished in the New World latitudes of their primeval home. On haciendas and in the wild, they multiplied in a manner that astonished and swiftly gave military supremacy to their 16th-century masters. Such was the power of the horse and European weaponry that the combination led commentators like Bartolomé de Las Casas to write that one man astride a war horse could lance 2,000 natives in a single hour. "Seventy," he declared, could devastate "a hundred islands."[2]

≈≈≈

The chronicle of Spanish exploration and settlement of what is now the southeastern United States has only recently begun to capture the sustained interest of historians. The same is true for the story of French efforts to settle the southeastern coast north of

Florida—what they called "New France"—in 1562 and 1564.

Aspects of the Spanish experience are finally being unearthed largely due to the efforts of archaeologists and scholars digging, on the one hand, through strata of sand and soil and, on the other, through mounds of archival papers, legal documents, and tax records in Spain, Latin America, and the United States. Established in 1565, St. Augustine, Florida, is heralded as the oldest continuously occupied Old World settlement on the North American continent. Researchers have only recently begun to learn about settlements like Santa Elena (1566-87)—St. Augustine's sister colony—whose historical significance is great but whose life spans were comparatively brief

and whose exact locations are yet to be found. In 1979, archaeological traces of Santa Elena were unearthed near the eighth hole of the Marine Corps golf course on Parris Island, South Carolina.[3]

Preceding the colonies of St. Augustine and Santa Elena, however, was the elusive and mysterious San Miguel de Gualdape. Historians have always considered the story of San Miguel a minor chapter in the chronicle of the Spanish colonization of America. But San Miguel spawned the legend of a verdant paradise that would later entice Spanish, French, and English adventurers to hazard their lives and fortunes attempting to colonize the coast of North America between what are now South Carolina and the Chesapeake.[4]

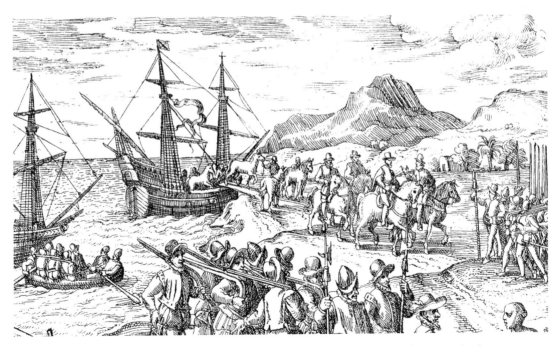

This detail from Theodor de Bry's Americae Pars Quinta *(1595) shows Francisco de Montejo landing with horses on the Yucatan Peninsula in 1527.*

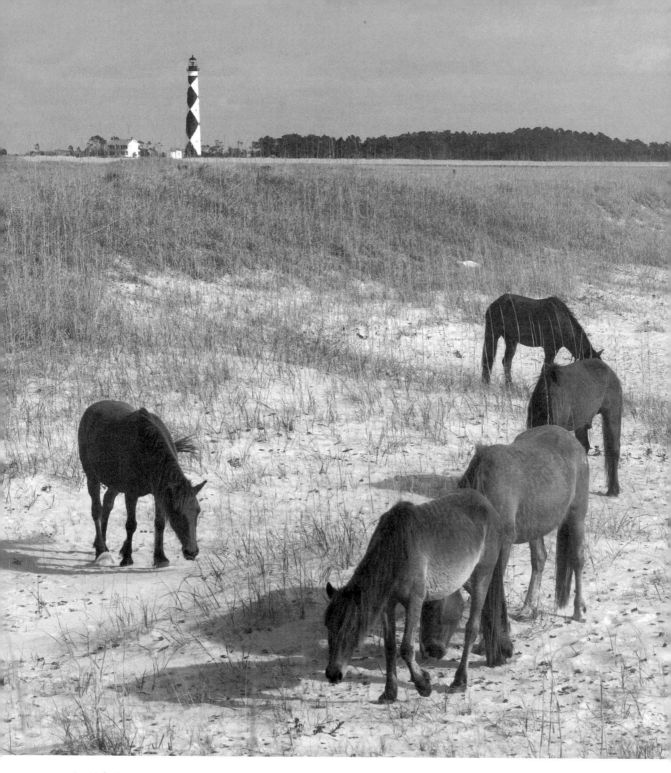

Shackleford Banks, near the site of the fabled village of Diamond City

The architect of this legend was Lucas Vasquez de Ayllón.

Lawyer, judge, trader, and sugar planter, Ayllón in 1523 received from Spain's King Charles V a license to branch out from Española and colonize the North American mainland. Ayllón's license gave him authority to establish settlements along the Atlantic coastline stretching northward from Florida to what is now Delaware Bay. Within that area, he planned to establish a "new Andalucia" somewhere between the same northern latitudes (32 to 37 degrees) as the Andalusian region of southern Spain.[5] He was looking for the fabled Indian "land of Chicora," supposedly rich in treasures, almonds, olives, figs, and peace-loving "giant" natives.

According to Ayllón, who had not yet been to the mainland, those natives also had horses. Such an assertion was hardly less fantastic than the accompanying belief that the giants were white-skinned and had brown hair that hung "to their heels."[6] The possibility of horses in that area of the New World was disputed by Peter Martyr. An Italian living in the Spanish royal court, Martyr was the chronicler of America's earliest empire builders. He was the first to herald the voyages of Columbus and the first to write about the New World's wonders and perils. But Martyr questioned the veracity of Ayllón's claim. He declared simply that the natives of Chicora were "too barbarous and uncivilized"[7] to have horses. In doing so, he signaled the first round of a centuries-old debate over the presence of horses on the coast of North America. The year was 1523.

In mid-July 1526, Ayllón charted a course for the coast of what is now South Carolina and set sail from Puerto Plata, Española. He commanded six vessels carrying 600 colonists—men, women, children, and a number of African and Caribbean slaves. The ships also contained seeds, tools, and livestock, including 89 horses, a herd large enough to reproduce and sustain itself. Soon after their arrival somewhere in the area of Winyah Bay and the south Santee River on the coast of what is now South Carolina, Ayllón's settlers found the area unsuitable for raising livestock or farming. Their relocation—north to North Carolina or south to Georgia—has for years been the subject of historical dispute.[8]

Wherever Ayllón's people settled later in 1526, they fared badly. Disease, desertion, and early frost soon began to decimate the population. Ayllón himself was one of the casualties, dying less than three weeks after the relocation of San Miguel. Without effective leadership, the colony faltered after only two months. Scarcely 150 of the original 600 settlers returned alive to Española. But when the cosmographer Diego de Ribiero created his famous *Map of the World* in 1529, he labeled the entire mid-Atlantic region north of Florida "Tiera de Ayllón"—"the Land of Ayllón"—a designation and a dream that stirred (and deceived) the imaginations of not only later Spanish explorers but French and English as well. On the map, Ribiero wrote that the mid-Atlantic region was the country that Ayllón "discovered and returned to settle, as it is well suited to yield breadstuff, wine and all things of Spain." Despite this optimistic sentiment, map readers must have been at least mildly discomfited by the next sentence, which read

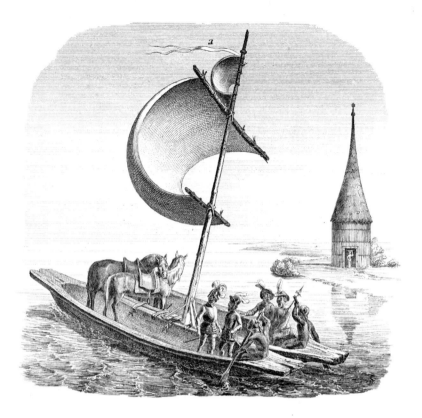

This 19th-century engraving purports to show Lucas Vasquez de Ayllón landing at "Cape Feare." The actual location of the cape continues to be a matter of debate. It has been variously identified with each of North Carolina's three capes—Cape Fear, south of Wilmington, and Capes Lookout and Hatteras to the north— as well as with Sapelo Sound, Georgia. However vague or imprecise the illustration's geography may be, it clearly indicates the early challenges of transporting large animals from ship to shore. In this instance, the vessel consists of a pair of dugouts strapped together, with makeshift mast and sails. The illustration is from Gonzalo Fernandes de Ovieda y Valdés's Historia General y Natural de las Indias *(1853).*

like an epitaph: "He died here of disease."[9]

Popular belief in the Spanish origin of the Shackleford horses has long been strengthened by the idea that, since Ayllón's license gave him permission to settle as far north as the Chesapeake Bay, he may have located there or on the Outer Banks after moving from the colony's first location. Subsequently, when the surviving settlers abandoned San Miguel, they would have left their horses behind. The members of that herd, which would have included brood mares, may have been the ancestors of the horses that then populated the Outer Banks.[10]

❧❧

The most resilient and most romantic explanation of the origin of the Outer Banks horses is not, however, the story of Ayllón's

ill-fated colony. What has fired the imaginations of writers of children's books and popular fiction is the idea that the horses were mustangs that swam ashore from sinking Spanish treasure ships.

It is certainly true that, from the beginning of Spanish voyages to the New World, mariners followed a clockwise southern route when intending to sail west. On their return trips from the Caribbean, they charted a northeastern route, taking advantage of both the trade winds coming off the continent and the Gulf Stream flowing northward at about 60 miles a day. That route placed the Spanish ships within approximately 20 miles of Cape Hatteras before they began sailing eastward to the Azores. The heavily laden galleons rode low in the water, making them vulnerable to the hidden shoals that reach out from the Carolina capes. Hard aground and beyond sight of land, the ships would have been helpless even in fair weather. In foul weather, they were doomed.

There are records of Spanish wrecks piled up off the Carolina coast in 1528, 1545, 1551, 1553, 1554, 1559, 1561, and 1564. There were probably many more.[11] How likely would it have been for horses to survive those wrecks and make it ashore? Since Spanish pilots knew of mid-Atlantic havens like Cape Lookout and the Chesapeake Bay, they may have tried to lay over in those refuges during perilous weather. Even if they failed to reach those destinations, attempting to do so would have brought them close enough to shore so that horses turned loose or thrown overboard may have been cast alive onto the beaches.

The relevant question, however, is not whether horses may have escaped drowning in the region that has come to be known as "the Graveyard of the Atlantic." Rather, it is this: Would Spanish horses likely have been on those ships at all? Cargo space was intended primarily for the transport of gold, silver, and other New World riches. The difficulties of shipping large animals were well known.[12] In fact, the Old World had no need for horses, which were in plentiful supply. Simply stated, the treasure galleons returning to Spain and sailing warily off the coast of North Carolina would have had no practical reason to carry horses.

By the 1580s, the English—under the early direction of Sir Humphrey Gilbert and, later, his half-brother, Sir Walter Raleigh—were mightily interested in the region the Spanish knew as Ajacan. The English called it Virginia, honoring their "Virgin Queen," Elizabeth I. Their ships *did* carry livestock, including horses. Like the Spanish colonists and missionaries who preceded them, those English men and women left behind few traces of themselves and meager documentary evidence of the animals that accompanied them. The evidence that does exist, however, has fired all sorts of speculation and controversy.

❧❧

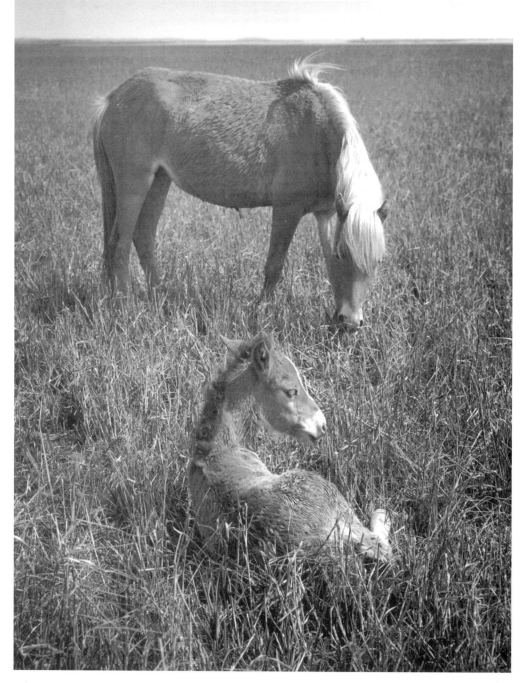

Mare and foal on Shackleford

> *"Besides this Island, there are many [others] . . . replenished with Deere, Conies, Hares and divers beastes."*
>
> CAPTAIN ARTHUR BARLOWE TO SIR WALTER RALEIGH (1584)

The first printed accounts by English explorers who visited the Carolina coast appeared in Richard Hakluyt's *The principall navigations, voyages traffiques & discoveries of the English nation*. Later known as *The Principal Navigations*, Hakluyt's monumental work was published in 1589 and in a second edition between the years 1598 and 1600.[1] Mainly a vast assemblage of previously printed travelogues and manuscript reports, *The Principal Navigations* provides the most important early records of Sir Walter Raleigh's Roanoke voyages from 1584 to 1590 and the costly efforts to establish an outpost of British civilization on the eastern shore of the New World. The first of those records is the report to Raleigh by Captain Arthur Barlowe, who, with Captain Philip Amadas and their Portuguese pilot, Simon Fernandez, made landfall in July 1584 in "the Countrey, now called Virginia."[2] Detailing what they saw and did there, Barlowe's report has often been cited in modern times as providing eyewitness testimony to the presence of wild horses on the Outer Banks in 1584.

Among many other things, Barlowe enthusiastically described the "incredible aboundance" of "Deere, Conies, Hares, and Fowle" he saw on Roanoke Island. He noted that one of the natives daily sent the Englishmen "a brase or two of fatte Buckes, Conies, Hares, [and] Fishe."[3] Conies—rabbits—thrive everywhere on the Outer Banks. But hares do not, which led David Beers Quinn to surmise that Barlowe may have seen two species of rabbits, the Eastern cottontail (*Sylvilagus floridanus*) and the marsh rabbit (*Sylvilagus palustris*), and confused the latter with the common hare (*Lepus timidus*) of Europe.[4] The real confusion, however, came later, and it was not Barlowe's.

In 1857, Francis L. Hawks published his two-volume *History of North Carolina*. A cornerstone of historical scholarship dealing with the Tar Heel State, Hawks's work paid close

attention to the Roanoke voyages and to Raleigh's drive to colonize the area. Hawks included transcriptions of contemporaneous publications dealing with those efforts. Not surprisingly, he gave special prominence to Barlowe's "The first voyage," which he reprinted from the second edition (1600) of Hakluyt's *Principal Navigations*.[5] While in most respects Hawks's version of Barlowe's report faithfully transcribed the original source, there is one sentence that varies significantly from Hakluyt. Hakluyt's text says that the neighboring islands were "replenished with Deere, Conies, Hares and divers beastes, and about them the goodliest and the best fishe in the world, and in greatest abboundance." Hawks's version (1857) says that the neighboring islands were "replenished with deer, conies, *horses*, and divers beastes, and *also at* them the goodliest and best fish in the world, and in *great* abundance [italics added]."[6] This was the first time that *horses* appeared in print in place of *hares*. It was one of three transcription errors, along with *also at* and *great* in place of *about* and *greatest*. Subsequent editions of Hawks's history in 1858 and 1859 repeated all three of the errors, including the word *horses* in place of *hares*.

The definitive (and correct) transcription of Barlowe's report appeared in 1955 when David Beers Quinn published his two-volume landmark, *The Roanoke Voyages: 1584-1590*, for the Hakluyt Society. But by that time, Hawks's mistaken reference to horses had been repeated in thousands of official publications intended to educate North Carolina's schoolchildren. The same passage has been cited countless times as evidence that horses

existed on North Carolina's Outer Banks even before the period of British colonization.[7]

There is no documentary evidence that Arthur Barlowe saw horses along the Carolina coast in 1584. In September of that same year, soon after Barlowe's return to England, Sir Walter Raleigh was already outfitting a squadron of vessels in preparation for a second New World expedition. The flagship of the small fleet was the queen's 140-ton *Tiger*, provided for the voyage along with more than 2,400 pounds of gunpowder. Elizabeth also gave Raleigh the authority to name the territories to be claimed "Virginia," in honor of the queen herself. Quinn estimated the total complement at about 600 men, including as many as 300 soldiers.[8] Led by Raleigh's cousin Sir Richard Grenville, their objective was in part to establish a naval base from which they could launch raids upon Spanish treasure ships lumbering off the Outer Banks on their return voyages to the Old World.

Since the garrison's first military commander was to be Ralph Lane, fresh from the Irish wars and an equerry (or horse master) in the royal stables, it is safe to assume that horses were to have a role in the expedition. When Grenville's fleet left Plymouth on April 2, 1585, it was not carrying horses. However, by the time they established their encampment at Mosquito (Tallaboa) Bay on the island of Puerto Rico in May, Grenville's soldiers were already conducting military exercises with two or three horses they had acquired or stolen from the Spanish.[9]

The open enmity between the English and Spanish in the 1580s did not prevent secret business transactions from taking place be-

tween the two groups. Odd as it may seem, amicable relations apparently existed among men whose countries were technically at war. As Helen Hill Miller notes, "The desire for consumer goods was apt to outweigh political loyalties" in the early days of New World colonization, "and illegal trade under French as well as Spanish auspices flourished there."[10]

While visiting with Spanish settlers in Española, Grenville and his men were entertained with hunting and a bullfight. For the hunting expedition, the Spanish provided saddled horses. In return, the English feasted the Spanish and bought some of their horses. At least a few of those horses—probably the stallions—may have been among those earlier used for the hunt and "appointed for every Gentleman and Captaine that would ride." Although there is no indication of how many Englishmen participated in the event, Grenville and Lane were not the only ones capable of hunting on horseback. The record indicates that they also bargained with the Spanish for other animals, including "mares, kyne [cattle], buls, goates, swine, [and] sheep."[11] The reference to mares is important because it indicates that the colonists intended to breed their own horses in Virginia. If those horses were allowed to roam freely, they would have been able to reproduce on their own.

On June 7, 1585, Grenville's expedition sailed northwest from Española. Cruising through the Caicos Islands and the Bahamas, the crews of the heavily laden *Tiger* and four other vessels sighted Florida on June 20. Three days later, they spied Cape Fear (what is now Cape Lookout), which Thomas Hariot's 1590 map ominously labeled "*promontorium*

tremendum" ("horrible headland"). It was there that unnumbered seafarers learned firsthand of the perils of the Carolina coast, where narrow underwater sand bars extend unpredictably seaward just a few feet below the surface for 15 or 20 miles. English maps would soon record the sites where some ships had already fallen victim to these waters.

Her Majesty's gallant *Tiger* nearly became one of them. As Grenville's flotilla, already reduced from seven to five vessels, sailed northward, it came to Wococon (what is now Ocracoke), where the entire fleet ran aground. The smaller boats were refloated without apparent difficulty, but the *Tiger*'s situation was more desperate. Raphael Holinshed, the 16th-century chronicler of English events and personalities, noted that "at the very entrance into the harborough, [Grenville's] ship strake on the ground, and did beat so manie strokes upon the sands, that if God had not miraculouslie delivered him, there had been no waie to avoid present death."[12] Everyone feared that the *Tiger* would be destroyed in the pounding surf. She may also have been dismantled from within by the shifting of her cargo, including perhaps thousands of pounds of frantic livestock.

Specific details of the disaster are lacking, but the struggle to save the ship lasted two hours. During that time, a large portion of her stores—including the provisions that were to supply the colony during its first year—was ruined, awash in the salt water that flooded the ship. Local tradition maintains that it was at that time that the horses and other livestock were unloaded or jettisoned and swam ashore. If they managed to avoid drowning in the surf,

This map from Thomas Hariot's A Briefe and True Report of the New Found Land of Virginia *(1590) shows 16th-century shipwrecks along North Carolina's Outer Banks.*

COURTESY OF THE NORTH CAROLINA COLLECTION, UNIVERSITY OF NORTH CAROLINA LIBRARY AT CHAPEL HILL

they would likely have been scattered along the ocean-side beaches of Ocracoke and Portsmouth islands.

But there are questions. How were the animals distributed among the vessels? Could they have been in one or more of the other four boats, and not the *Tiger*? If so, it is possible that at least some of the animals were tossed overboard in order to lighten and thereby refloat those smaller boats. Following the storm and the grounding of the *Tiger*, the flagship was careened for repairs. If the animals were still aboard the ship, they would have been unloaded at that time. If they were not hobbled or staked, Grenville's livestock may have been left to fend for themselves, at least temporarily. In fact, allowing the animals to roam freely could have been the original intention. The Outer Banks are excellent grazing areas. The ocean, sounds, and inlets obviate the need for fences. In the Caribbean, it had long been a New World mandate of the Spanish to "seed" islands with feral cattle and hogs for future hunting, both to provide meat for the table and (as Grenville's company experienced in Española) for manly sport. The English probably intended to do the same with their livestock.

Grenville's own words reveal that some of his livestock survived the grounding of his

fleet, at least for a short time. Twelve days following his return to England in October 1585, he wrote to Sir Francis Walsingham, "I have possessed and peopled [Roanoke] to her Maiesties use, And planted it with suche cattell & beastes as are fitte and necessary for manuringe [i.e., populating and managing] the Country and in tyme to give reliefe with victuall."[13]

Because of the catastrophic loss of provisions, however, Sir Richard reduced his company on Roanoke Island by two-thirds. Even Grenville himself bailed out. He left Ralph Lane in command of a reduced contingent of soldiers, most of whom proved to be fatally unsuited to the task of supporting themselves by living off the land. Like other English veterans of his day, Lane soon showed himself inept and heavy-handed in dealing with New World natives.

On August 25, 1585, Grenville ordered his ships to strike for England. He promised Lane that the colony would be resupplied by Easter of the following year. Until then, the orders were to establish a settlement, reconnoiter the area, record its resources, communicate with the Indians, and somehow persuade them to indefinitely feed 108 disconsolate Englishmen. As Edmund S. Morgan dryly observed, the natives "were not prepared for the company that came to stay."[14]

Within days of his departure from the Outer Banks, Grenville came upon and took the *Santa Maria*, a Spanish treasure ship of 300 to 400 tons laden with gold, silver, pearls, ginger, sugar, cochineal, and ivory. At the same time, Lane's prospects back on Roanoke Island were still hopeful, at least for a while. On September 3, 1585, he described Virginia as "the goodliest and most pleasing territorie of the world" and offered the following optimistic assessment: "If Virginia had but Horses and Kine [cattle] in some reasonable proportion, I dare assure my selfe being inhabited with English, no realme in Christendome were comparable to it."[15] His optimism would be short-lived.

No account of the colonists' activities during the next few months has survived, though it is known that they explored the region northward about 130 miles to the Chesapeake and southward about 100 miles to the village of Secotan. Travel was mostly by small boat over shallow waters and protected bays. The few comments Lane offered about movements over land indicate that they were undertaken by foot soldiers living on short rations and packing their own equipment. Thomas Hariot was likewise silent about their mode of travel, so there is no evidence that they employed horses. Neither is there any indication that the horses and cattle that Lane hoped for were included in later efforts to resupply the settlement at Roanoke.

For all but 20 days of the colony's residence at Roanoke, the English relied on food provided by the natives.[16] It might have been possible for friendly Indians to adequately supply a small group of settlers with enough provisions for a short time. But doing so for more than 100 (often surly) men for at least eight months would have been an unrealistic challenge, even had the growing seasons been productive. So desperate did the English become that, during an inland expedition in search of gold mines, Lane and his party of 40 men

killed and ate two bull mastiffs—war dogs that had accompanied them either from England or Española.[17]

By the spring of 1586, relations with the natives had deteriorated to the degree that they refused to supply the English with any provisions. Attempting to starve them out, the Indians also destroyed the fishing weirs they had constructed for the settlement. Lane then divided up his company into small bands and sent them off to fend for themselves. A group of 20 was sent to Croatoan. Another group was dispatched to Hatarask and the mainland. Lane noted that they lived on "Casada [cassava] and oysters."[18]

It is reasonable to assume that Lane's men—facing the prospect of starvation— would have attempted to retrieve the livestock that made it to shore during the grounding of the *Tiger*. Under the circumstances, had his soldiers come upon any of the animals, including the horses purchased in Española, they would likely have hunted and eaten them.[19] The natives would have done the same, both to provide meat for themselves during the springtime, when their own provisions were low, and to prevent the English from acquiring a source of food.

Fortunately for the history of colonial America, Lane's company included a scientific and cultural research team led by Thomas Hariot, who had earlier served as a tutor in the household of Sir Walter Raleigh. The group also included artisans of various kinds and the painter John White, who would return to lead his own very different group of Roanoke settlers in 1587.

While the overall objective of establishing a settlement in 1586 was in most respects a failure, the venture's signal achievement was the collaboration between Hariot and White that resulted in the publication Ivor Noel Hume calls "the cornerstone of American natural history." Karen Ordahl Kupperman is equally effusive, describing Hariot's account of Native Americans as "the best [record] done anywhere in America before the advent of photography."[20] The book is Thomas Hariot's *A Briefe and True Report of the New Found Land of Virginia*.

First published in 1588 and then with Theodor de Bry's engravings of John White's drawings in 1590, *A Briefe and True Report* is, next to Hakluyt's *The Principal Navigations*, the most important early document related to Carolina Algonquian culture and the story of 16th-century English colonization. Not much in the way of Native American life and the natural world escaped Hariot's eye. He observed everything and recorded everything he observed. Among many other things, Hariot described the religious beliefs of the area's "naturall inhabitants," along with their agricultural practices and methods of hunting and fishing. He listed and described the plants and animals he saw. Deer and conies "of a grey colour like unto hares"[21] were included, along with squirrels, bear, fowl, and fish. He nowhere mentioned horses. This does not mean that there were none beyond the regions Hariot reconnoitered. But if he saw any horses—wild or domesticated—in the Roanoke area, it is likely he would have said so.

When the supply ship Grenville promised by Easter failed to appear, Lane's situation be-

came increasingly desperate. On June 11, the arrival of Francis Drake's fleet, returning to England from its plundering of Spanish settlements in the West Indies, offered an infusion of supplies, watercraft, and some food. But as fate would have it, an early and murderous hurricane blew ashore on June 13, scattering the entire fleet and destroying many of the smaller boats. At that point, Lane gave up. He requested and was granted passage back to England for himself and his company. They arrived safely at Plymouth on July 28, 1586.

Only days after Ralph Lane abandoned Roanoke, a supply ship sent by Raleigh arrived. Sir Walter's ship was followed two weeks later by three led by Grenville. Of course, they were too late, even though this time they had taken no side trips to horse-trade or hunt with Spanish dealers in the West Indies. Raleigh's ship returned with its stores to England. After a couple of weeks, Grenville also returned, privateering along the way.

At Roanoke, he positioned a small garrison of about 15 men. Left on their own, the holding party was attacked and probably destroyed by the Roanoke Indians, never to be seen again. It was this forlorn band of half-starved Englishmen that David Beers Quinn called the first "lost colonists."[22]

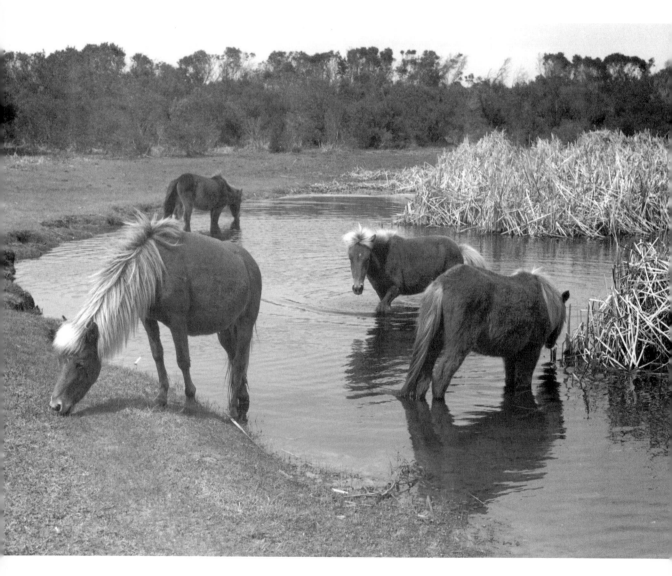

The mare in the foreground was named Delta. Born in 1988, she was last seen in March 2003. Her foal, Deniro, appears here following Delta out of one of Shackleford's freshwater ponds. Deniro was born in 1997.

Attempting to capitalize on the accumulated experience of the Roanoke voyages of 1584, 1585, and 1586, Sir Walter Raleigh dispatched to Virginia another group of settlers in three ships on May 8, 1587. This time, John White commanded the group as its governor. Once again, Simon Fernandez navigated. White's account of the voyage indicates that they intended to retrace the path of Grenville's 1585 voyage, including stops in the West Indies to replenish their water supply and gather fresh fruit. Although White does not say they wanted horses, he did intend to buy livestock—specifically, sheep in Puerto Rico and cattle in Española. Under Fernandez's direction, however, and for reasons that remain curious, they sailed past Española without the cattle and other stores that would have enabled them to fare better in the coming months.[1]

Unlike the company captained by Grenville that consisted entirely of men, White's settlers included men and women, one of whom was the governor's pregnant daughter, Eleanor, accompanied by her husband, Ananias Dare. (On August 18, 1587, Eleanor gave birth to a daughter, Virginia Dare, the first English child born in the New World.) The group's objective was to establish a colony not on Roanoke Island but at some deepwater harbor in the Chesapeake Bay, according to Raleigh's written orders. As the company sailed northward off the Outer Banks, it anchored for a while as White took a group of men to meet the holding party left by Grenville in 1586. Historians may never determine conclusively why the entire collection of 108 settlers then also landed at Roanoke and why, once there, White could not persuade Fernandez to deliver them to the intended destination farther north.

Whatever the reasons they landed and remained there, White's company found the Roanoke settlement to be a melancholy outpost. The earthen fort earlier constructed under Grenville's command had been razed and its main building torched. Sir Richard's relict garrison had long since disappeared, except for what the governor plaintively described as "the bones of one of those fifteene, which the Savages had slaine long before." The only animals White reported seeing were deer. He noted that some of the fort's outbuildings were still standing, but they were overgrown with melons, "and Deere [were] within them, feeding on those Mellons."[2]

Soon after their arrival at Roanoke, White's men undertook the reconstruction of the settlement, but they quickly discovered that building adequate shelter was the least of their challenges. They had reason to fear hostile natives. Within a week, one of their company, George Howe, was ambushed and killed while crabbing by natives still chafing at the arrogant and at times brutish treatment they had received at the hands of Ralph Lane and his group. And although they had no way of knowing it, even nature appeared to be conspiring against the colonists and every living creature in the area.

John White already had a menacing hint of what was to come. In 1585, he and Hariot had learned much about the region as they recorded, in sketches and words, details of the everyday lives of the Indians. At one point in his account, Hariot noted that the natives were eager to learn of the Christian religion, especially when it appeared that the resolution of some crisis called for divine intervention from the Englishmen's God. "On a time also," wrote Hariot, "when their corne began to wither by reason of a drouth which happened extraordinarily, fearing that it had come to passe by reason that in some thing they had displeased us, many [natives] woulde come to us & desire us to praie to our God of England, that he could preserve their corne, promising that when it was ripe we also should be partakers of the fruite."[3]

What neither Hariot nor the natives fully understood was that the dry weather they were experiencing was the leading edge of a natural disaster of immense magnitude, the brunt of which would be felt by White's settlers at Roanoke in 1587. For it was between 1587 and 1589 that the area from the Chesapeake to Florida experienced what scientists describe as the region's "most extreme drought in 800 years."[4] The privations that Lane's colonists experienced in 1586 have long been known, and the relentless demands of the English for food were a major factor in the breakdown of their relationship with local tribes. But it has only recently come to light that the Native Americans were also experiencing severe food shortages during that period.

By studying the tree-ring patterns of centuries-old bald cypress trees along Virginia's Blackwater and Nottoway rivers, a team of dendrochronologists in 1998 was able to reconstruct Virginia's rainfall patterns for the years 1185 to 1984. It discovered not one but *two* periods of drought, which exactly coincided with the attempts to establish English settlements on Roanoke Island in 1587 and at Jamestown in 1607.

The earlier drought lasted three years. It

affected the entire southeastern region of North America but was particularly severe in the Chesapeake area near Roanoke Island.[5] Earlier experiences had taught the English that survival in the New World would depend, at least for the first year, upon the willingness of the natives to provide food. Historians have long attributed their reluctance to do so to the natives having no great stores to draw upon and their coming to see the English as parasites who could not be trusted. What now must be added to the equation is the likelihood that by 1587, the native inhabitants of coastal Carolina were themselves confronting starvation. No eyewitness account of the drought's devastation on Roanoke has surfaced, but in a contemporary letter to the king of Spain, Pedro Menandez Marquis reported that it was so dry in Florida that no corn at all was planted in 1588.[6] Simply stated, the besieged natives of Roanoke could not share or trade what they did not have. That situation led to dismal prospects for the survival of White's fledgling colony.

In his narrative of the 1587 voyage, White did not say that the colony was in great danger. Like other early promoters of English colonization, he saw nothing to be gained by being pessimistic, at least on the record. Bad news would have been closely guarded

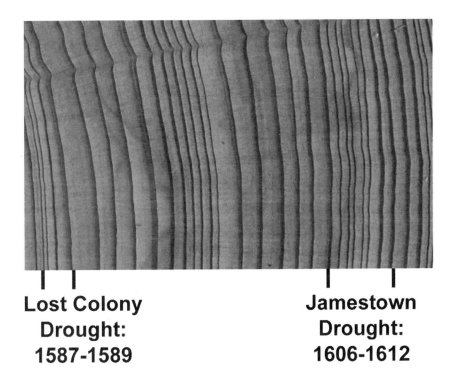

Lost Colony Drought: 1587-1589

Jamestown Drought: 1606-1612

This bald cypress tree-ring pattern shows the droughts of 1587 and 1607.
COURTESY OF DANIEL GRIFFIN, UNIVERSITY OF ARKANSAS TREE-RING LABORATORY

information. The main reason why White himself may have agreed to return to England scarcely five weeks after he planted his settlers at Roanoke was to make the case personally "for the better and sooner obtaining of supplies, and other necessaries."[7]

John White sailed homeward on August 27, 1587. Under such a formidable array of hostile conditions, could any of the men, women, and children who bade farewell to their governor have realistically expected to be alive to witness his return? The story of White's heroic efforts to do so is well known. After two false starts—during one of which in 1588 he was nearly killed by French pirates—White finally did return in 1590. At Roanoke Island, the governor found nothing but the destroyed remnants of some of his forsaken belongings and the word *Croatoan* scored upon one of the entrance posts the colonists had erected for their woeful palisade.[8] All was indeed lost. Governor White was too late to do anything but add another chapter to the lengthy and sorrowful history of New World English and Spanish settlements doomed by the failure of supply ships to appear on schedule.

But what of the animals—particularly the larger ones, the English cattle and Spanish horses—imported by Ayllón, Grenville, and possibly others? If life on the Outer Banks during the drought was a struggle for both English and Native American communities, animal populations must also have confronted enormous challenges. Because of prolonged exposure to sun and heat and the amount of salt in their diet, free-roaming Banker horses would have needed more fresh water than their counterparts in captivity. Further, popular

wisdom and scientific observation indicate that, in times of famine or drought, feral horse populations are limited by a natural form of birth control. Under such conditions, there is higher mortality among older horses on the one hand and foals on the other. Those who know wild horses and their environment recognize and accept this stern equilibrium as a reality of the natural process.

Yet the tree-ring patterns do indicate that rainfall increased dramatically in 1589, possibly as a result of increased storm activity. And it is worth noting that when John White returned to the Outer Banks in August 1590 and went ashore on Hatteras, he found a "very sufficient" amount of fresh water to replenish his empty barrels.[9] His party had to dig for it in the sand, just as Banker horses do today.

The great drought of 1587-89 delivers another challenge to the idea that Spanish horses transported to the Outer Banks in the 16th century could have survived into the 17th. But Banker horses have always braved the odds. Within the space of a generation, there *were* horses and livestock in substantial numbers nearby in the area of Jamestown, Virginia.

❧❧❧

The importation of horses by the English during the early years of Virginia's colonization was overshadowed by demands for other livestock, especially goats and cattle. This was due to the limited use horses had at first, compared to livestock that could more readily provide food, dairy products, and hides. The high cost of shipping horses was also a factor. In the 1630s, for example, the Reverend Francis Higginson of Salem, Massachusetts, complained that the cost of transatlantic passage

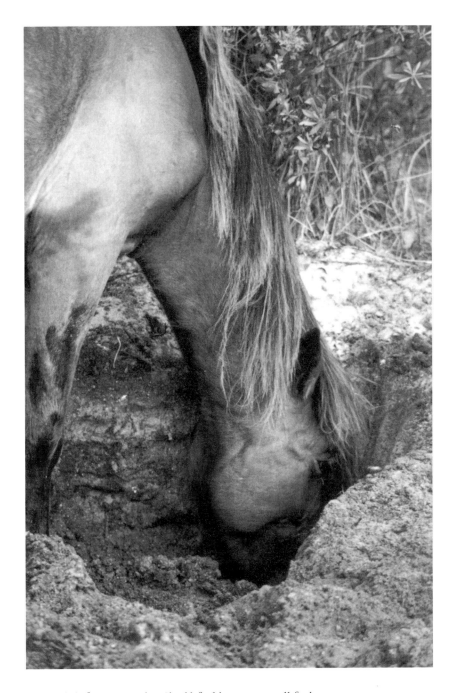

Popular belief maintains that Shackleford horses can smell fresh water even when it is a foot or two below the surface. This horse knew exactly where to dig. It is drinking fresh water from an underground source.
COURTESY OF THE FOUNDATION FOR SHACKLEFORD HORSES, 1996

was "wondrous dear, as £5 a man and £10 a horse."[10] Still, eight horses, including two mares, were among the animals loaded onto the *Blessing*, one of the supply ships in the fleet dispatched to Jamestown in 1608.[11] In 1619, the *Falcon* arrived with 36 passengers, 52 head of cattle, and four mares. The following year, the Counsel for Virginia shipped 500 "tenants," 100 to 200 cattle, 400 goats, "twenty Mares, [and] fourescore Asses to be procured from France."[12]

Despite the gruesome record of early setbacks—Indian massacres, disease, starvation, cannibalism—settlers soon discovered that domestic animals did well in Virginia. In 1620, one observer noted that the "Cattle which we have transported thither, (being now growne neere to five hundred,) become much bigger of Body, then the breed from which they came." He added that "the Horses [are] also more beautifull and fuller of courage. And such is the extraordinary fertility of that Soyle, that the Doe's of [Virginia's] Deere yeelde two Fawnes at birth, and sometimes three."[13] Unlike deer, horses rarely give birth to more than one offspring at a time, but in Virginia in the 1640s and 1650s, in feral or semi-feral conditions, horses were multiplying rapidly. By the 1660s, there were so many horses ranging wild in Virginia that they were a nuisance to crops—especially tobacco—and to the pasturage of other livestock. Robert Beverly recorded in 1703 that young people took "great Delight" in capturing wild horses. But the horses often bested their mounted pursuers. The feral animals were so swift that the hunters were more likely to wear out and ruin their own horses in the pursuit than to catch them.[14]

By the 1650s, Virginia Tidewater settlers were beginning to crowd the Chesapeake. Some made their way southward, populating settlements along North Carolina's Outer Banks. Land ownership there began to be formalized by the Lords Proprietors of Carolina in 1663, when the first royal charter was issued to Sir John Colleton, who established a "plantation" on Colington Island, west of what is now Kill Devil Hills, for the specific purpose of raising cattle and horses.[15]

While much attention has been given to whaling and fishing on the Outer Banks, early records indicate that raising livestock was important to coastal settlers throughout the colonial period.[16] One of the chief incentives for doing so was to avoid paying fencing taxes by grazing animals on the barrier islands, where fences were unnecessary. As animal populations increased, they edged southward, the only direction available to them on the narrow strips of sand. The shallow sound waters allowed for easy migration even where inlets separated islands from each other. Human communities were established at Portsmouth and Ocracoke to promote the transport of goods to and from inland ports, but they also vastly increased the number of livestock on the Banks. In the late 18th century, an unidentified reporter noted that a single resident of Portsmouth—at the time, one of the two largest communities on the Banks[17]—had "of his own mark, Sheared 700 head of Sheep, had between two hundred & fifty, & three hundred head of cattle & near as many Horses."[18]

When Edmund Ruffin of Virginia visited Core Banks in 1856, he reported seeing "some hundreds" of horses ranging "at large—and wild."[19]

Like their counterparts in and around the Chesapeake, settlers on the Outer Banks seem to have preferred the short, hardy variety of horses that took readily to the marshes and beaches. Those horses were likely the progenitors of at least some of the horses that live in just three sites on the Outer Banks today.[20] However, determining the origins of colonial horses is never a simple matter. Doing so for *feral* horses is maddeningly complex, and the wild Banker horses present special challenges. Part of the reason for the difficulty is that in the late 17th and early 18th centuries, the American Southeast was a maze of multiethnic business and political interactions. Spanish, French, Dutch, English, and Native American settlements and trading posts were scattered throughout the region. At times, the groups cooperated with each other openly or clandestinely. At other times, they actively pursued each other's interests. And no other creature reflects the consequences of those ethnic, economic, and political crosscurrents more than the horses of the American South. Simply stated, there is no single breed that can be identified as the *main* source of any of the Outer Banks horses.[21] Whatever the origin—or, more accurately, the origins—of the colonial Banker horses, a couple of facts are certain: They found and occupied an ecological niche on the shores of North Carolina, and their descendants have been content to live there for at least three centuries.

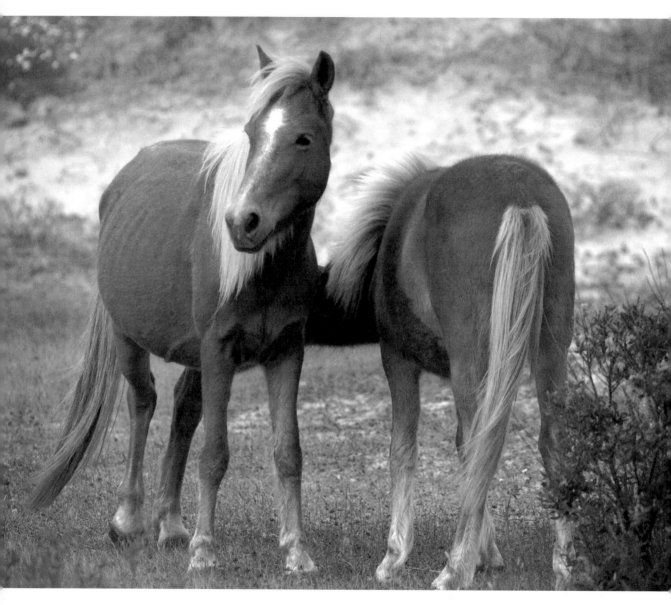

Marilyn and MissIsabel on Shackleford

"They were the horses we rode as children, and the horses our children rode."

WILSON DAVIS, PAST PRESIDENT AND DIRECTOR,
FOUNDATION FOR SHACKLEFORD HORSES, INC.

In 1713, the islands known today as Core Banks and Shackleford Banks were officially deeded to John Porter. Porter soon sold his property to Enoch Ward and John Shackleford, who divided it in 1723, Ward getting Core Banks and Shackleford taking the island that presently bears his name.[1]

Today, Shackleford is separated from Core Banks and Cape Lookout by Barden Inlet, but that separation is of relatively recent origin. Before the hurricane of 1933, Shackleford and Core Banks were actually a continuous—though erratically shaped—body of sand. A channel disconnected the two at high tide. But at low water, that channel—known simply as "the drain"—could be traversed on foot. This meant that for more than two centuries, free-ranging livestock—cattle, sheep, goats, hogs, and horses—had about 57 miles of barrier-island range pretty much to themselves. The exception was on Shackleford, the site of several human settlements, including one, Sam

Windsor's Lump, named for a slave who was bequeathed his freedom and 50 acres of land by Abraham Wade in 1801. Other communities on Shackleford were Wade's Shore, Mullet Pond, and Bell's Island, which was renowned for the bountiful persimmon trees that grew wild there. The largest and most legendary community was Diamond City, so called for its proximity to the diamond-patterned Cape Lookout lighthouse.[2]

Although many of Shackleford's early residents were Virginia transplants, enterprising New Englanders were also in the area.[3] They were attracted to Shackleford for employment in the mullet fishery and by the profits offered by seasonal shore-based whaling. On Shackleford, when they were not fishing or processing whales, people lived in enclosures, while sheep, cattle, hogs, goats, and horses roamed free. Homes were constructed of native timber from the maritime forest and lumber salvaged from the shipwrecks cast upon

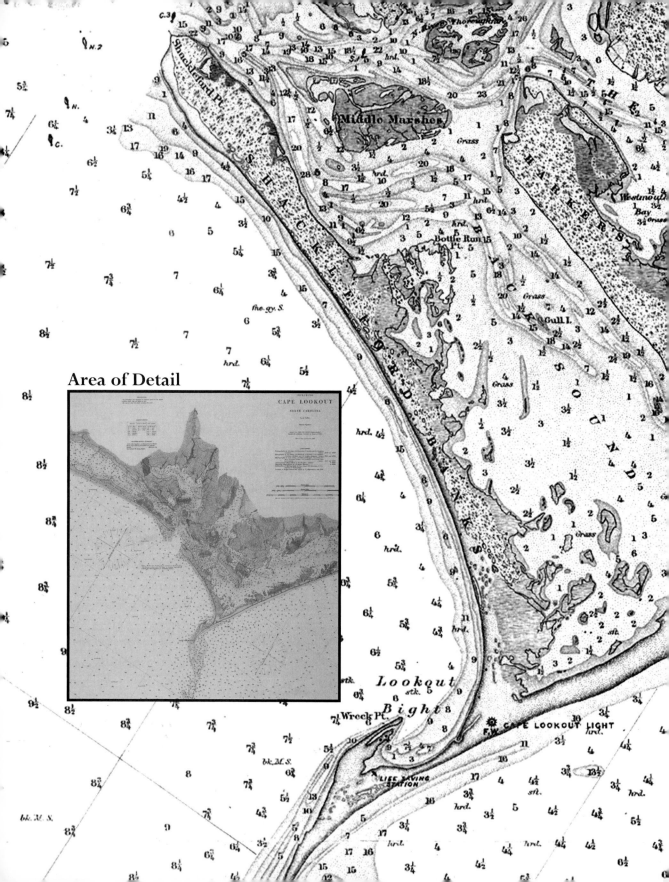

Area of Detail

the shore with grim regularity. By all accounts, the independence and self-reliance that Bankers enjoyed on Shackleford throughout the 19th century mirrored life in the maritime outposts of colonial America.

In the late 1890s, everything changed permanently. Between 1896 and 1899, a series of powerful storms ravaged the North Carolina coast. Earlier storms in 1878 and 1879 had already begun to alter Shackleford's natural environment and had severely battered its human communities. But those storms were merely warmups for the main act. No one had seen anything like the tempests that have become known as the "monster hurricanes" of the 1890s.

The most ferocious was the San Ciriaco storm, which plowed ashore on August 17, 1899. Modern reckoning puts this hurricane at category four, possibly five, with estimated blows of 140 miles per hour. It raged at varying intensities for two days. On Hatteras, a United States Weather Bureau eyewitness reported, "The howling wind, the rushing and roaring tide and the awful sea which swept over the beach and thundered like a thousand pieces of artillery made a picture which was at once appalling and terrible and the like of which Dante's Inferno could scarcely equal."[4] On August 21, the *Washington Gazette* described the "complete wreck" of Ocracoke. Two churches and 33 homes were destroyed, and hundreds of Banker horses, sheep, and cows were drowned.[5] When the San Ciriaco winds subsided, Shackleford residents found that gardens and most of the island's topsoil had vanished. Freshwater wells were inundated. If they were not altogether destroyed, cottages were separated from their foundations. "To add insult to the already intolerable injury," Joel Hancock noted, "the ransacking waters had uncovered graves in the local cemetery and left bones and caskets strewn everywhere."[6]

No record has surfaced indicating the loss of animals on Shackleford, yet in spite of the ruination, there is evidence that at least some horses survived. In the files of the North Carolina State Archives is a photograph by M. B. Gowdy showing a horse roundup. Although it is not possible to pinpoint the location, a note indicates the scene was "near Beaufort," and therefore likely Shackleford Banks. The picture is remarkable for several reasons. First, the date is 1907, just eight years after the San Ciriaco storm. Second, the roundup included women and children as spectators, indicating that it was likely a festive gathering of families. Third, the animals are clearly Banker horses, several of them old enough to have weathered the combined assaults of the great storms of the 1890s.

But even if horses remained on Shackleford, the island was still unsuited for year-round habitation by people. Within a few years, all the residents of Shackleford Banks relocated to other places. Some dismantled

Left:

This detail from the 1888 coastal survey shows Shackleford Banks connected to Core Banks. The map also indicates the maritime forest that blanketed Shackleford. The density and extent of the forest, along with Shackleford's protected position behind Core Banks, could have made it practically an incubator for wild horses.

U.S. COAST AND GEODETIC SURVEY MAP COURTESY OF THE NORTH CAROLINA COLLECTION, UNIVERSITY OF NORTH CAROLINA AT CHAPEL HILL

Following the destructive hurricanes of the 1890s, little remained of the human communities on Shackleford except for a few gravestones in a cemetery located on the relatively high ground of the island's western maritime forest.

what remained of their houses and floated them on skiffs across Back Sound, to be replanted on Harkers Island or in Morehead City or Salter Path. But in subsequent years, they and their descendants continued to maintain and even strengthen their ties to Shackleford. They heard and responded to what Susan Yeomans Guthrie described as an "urgent call . . . to return to the land of their forefathers,"[7] where they assembled seasonal fishing crews according to the traditional patriarchal system. Led by such men as Martin Guthrie, Calvin F. Willis, and Charlie Hancock, the crews continued to fish the ancestral waters, living in camps on the sites of some of the old settle-

ments.[8] Others continued to graze cows, sheep, goats, and horses on the Banks. Later, those sites became the locations of new cottages where descendants of the original Bankers returned periodically. According to Captain Josiah Bailey, a legendary storyteller, their purpose was to harvest nature's abundance, to recall "stirring memories remaining only in the blood, . . . to tend the totems over their sacred ground, and in so doing, to renew their spirit."[9] Rounding up horses in annual "pony pennings" became an important focal point for this renewal. Each year, usually in the summer, they drove the herds into cedar corrals to rope and brand colts and fillies

COPYRIGHT-1907.
M.B.GOWDY

Described as being "near Beaufort" (and therefore most likely on Shackleford Banks), this 1907 roundup
suggests that enough horses survived the storms of the 1890s to reproduce and create viable herds. The
photograph also indicates that the early-20th-century roundup was a family affair that included women
(upper left) and children as spectators.

born during the previous months and to see to older horses needing care. The pennings attracted outside attention.

When Colonel Fred Olds—known as the father of the North Carolina Museum of History—traveled from Raleigh to visit the area in 1925, he described "approximately 3,000" horses living on Shackleford Banks and Core Banks.[10] The following year, *National Geographic* magazine writer Melville Chater toured 2,000 miles of North Carolina roads by "motor coach" from the mountains to the coast. His seashore route took him to Beaufort, where he learned that "for centuries [wild horses] have been roaming on the Banks, and current tradition has it that they are descended from Barbary ponies which were brought over by Sir Walter Raleigh's colonists." From Beaufort, Chater sailed to Shackleford (which he called "Beaufort Banks"), where he witnessed a roundup by local people at "Diamond Pen." Named, like Diamond City, for its proximity to the Cape Lookout Lighthouse, the pen was made of timbers from old wrecks. "Perched on the pen's top rail," reported Chater, "we took lens shots at the enclosed jam of 200 horses, as they reared and kicked each other into a state of bloodied noses and wildly rolling eyes." Amid the sand-spray and confusion, "some of the herders lassoed and cut out colts for branding or sale. Others yelled out their branding marks, recognized on mares, and

The idea that Shackleford's horses are descendants of those dispatched by Raleigh on the ships commanded by Sir Richard Grenville in 1585 is dramatically sustained by one of the large paintings on display in the Beaufort, North Carolina, post office. Entitled Sir Walter Raleigh's Sand Ponies, *it is one of four murals by Russian-born artist Simka Simkhovich (1893-1949). Commissioned by the Federal Arts Program in 1940, the group also includes depictions of the mailboat* Orville W *steaming toward the Cape Lookout Lighthouse, a waterfowl hunting scene, and the wreck of the* Chrissie Wright.*

The sand ponies mural, popular with visitors to Beaufort, shows the remains of a shipwreck on the beach and utility poles that once carried electricity from the mainland to Cape Lookout.

Gilbert Russell of Harkers Island with foal about to be removed from Shackleford Banks to the mainland, 1946
COURTESY OF NORTH CAROLINA STATE ARCHIVES

claimed the accompanying foals."[11] This process of annually branding foals born the previous year continued into the 1970s. In August 2002, Margaret W. Willis remembered seeing "only one living horse [on Shackleford] that has a brand on it."[12]

Melvin Chater numbered the horses living along the Outer Banks at between 5,000 and 6,000.[13] There is no way to gauge the accuracy of that estimate. Today, even with spotter planes, it is difficult to count horses that move at will in and out of secluded dunes and woodland. But it is known that the number of horses on the Outer Banks in Chater's time was high. In fact, it was far too high for some influential Tar Heels, who had ambitious plans for the barrier islands. In the 1930s, those plans called for development for vacationers and tourists, a national seashore park on Hatteras Island, and lots of commercialization to serve the hordes of anticipated visitors. Soon, the plans would also call for the complete elimination of free-roaming livestock, including Banker horses.

The decimation of the herds of wild horses on the Outer Banks did not begin with land development, however. It began, predictably, with a devastating hurricane. Rather, it was a pair of hurricanes that delivered a one-two blow to the Outer Banks in 1933. The first storm, a category two, passed east of Ocracoke on August 22. On September 15, the second one came ashore, hitting Cape Lookout dead-on. A category three—and the most murderous natural assault to the area since 1899—the September storm overwashed vast stretches of the Banks. It opened two new inlets, one south of Portsmouth village and the other at Cape Lookout just west of the lighthouse. Known simply as "the storm of '33," it claimed the lives of 21 people in North Carolina and thousands of domestic and wild animals. An unknown number of Banker horses perished. But not all. Like earlier hurricanes, the 1933 storm failed to kill all of the wild horses on the Outer Banks.

What nature could not do in 300 years, men with rifles nearly accomplished in less than a decade. The removal of wild horses on the Outer Banks was carried out by massive Depression-era roundups and shootings legislated by the state of North Carolina. The eradication was supported by the United States Forest Service and the Federal Bureau of Fisheries, which asserted that grazing animals ate the vegetation that prevented loss of sand, and subsequently contributed to the erosion of the barrier islands. If the Banks were to erode, officials at the time feared that the inlets would also be lost, which would threaten the state's commercial fishing industry. In addition, on May 5, 1935, the *Raleigh News & Observer* reported that "those little ponies, redolent of the romance of legend and that high adventure which hovers over their historic haunts, are destined to make way for the path of progress expected to take the form of a national park that would extend 100 miles along the coast and include the 'banks' where they now roam." By 1937, Cape Hatteras National Seashore was established, and the "path of progress" became N.C. 12.

On June 14, 1938, the Raleigh paper announced that the "final extinction of the

Right:
Brand records, Carteret County Courthouse

Year.	Month.	Day.	No.	NAME AND RESIDENCE.	Brand.	Location of Brand.	Ear Mark.	Description of Mark.	REMARKS.
1891	April	25	12	T. C. & J. W. Fulcher Smyrna	FF	on left Shoulder			
1891	April	25	13	Charles L. Davis Davis Shore				Crop of let the Right ear.	
1891	April	29	14	William J. Salter Hunting Quarter				Swallowfork Right, Crop & Slit the Left ear	
1891	May	7	15	A. M. Hamilton	AMH	A on left Shoulder & MH on left hip			
1891	May	11	16	Wm R Dill Beaufort				Slit the right ear Overbit Lef ear.	
1891	May	11	17	Wm R Dill Beaufort	W	on right hip			
1891	May	18	18	Wm P Davis Davis Shore	WPD	W on left Shoulder P.D on left hip			
1891	June	1	19	George W Fulcher Piny Point				Crop & two Splits the Right ear & two under bits the left ear	
1891	June	1	20	Lewis H Mason Piny Point	H	on left Shoulder on left hip			
1891	June	1	21	Charlie & Joseph W Fulcher	J C	on left Shoulder on left hip			

47

Banker ponies, wild horses which have roamed the Outer Banks for three centuries, was begun this morning." Armed with high-powered rifles and dumdum bullets, two hunters continued the work of removal that had begun several years earlier as a result of special North Carolina legislation aimed at removing the animals from the Banks.

Not all of the Banker horses were lost. In the 1950s, there were still enough alive to create on Ocracoke Island the first (and only) mounted Boy Scout troop in the United States. According to a 1956 article in *Boy's Life* magazine, 70 horses ran wild on Ocracoke. Two years earlier, 10 horses had been culled from the herd, "and Troop 290 got its start."[14] The Scouts branded, tamed, and trained the horses and used them for such Scouting and public-service activities as riding in parades and spraying mosquito-infested salt marshes. The troop lasted only a few years, until its members aged out of Scouting.[15] Today, a semi-feral herd of 25 to 30 Ocracoke horses is afforded humane care and protected from automobile traffic—and from accusations of overgrazing—within a fenced pasture of approximately 160 acres. Their caretaker, the National Park Service, describes them as "Ocracoke's Favorite Residents."[16]

The Ocracoke Boy Scout troop was not the first or only time Banker horses engaged in uniformed service. Until 1915, United States Lifesaving Service crews used horses for beach patrol and rescue operations. While hauling the heavy lapstrake surf boats was probably assigned to larger, imported draft animals, local Banker horses were likely candidates for beach patrols. And in the 1980s,

Banker horses carried park rangers on beach duty at Cape Hatteras National Seashore.

By the 1950s, wild horses and livestock were cleared from Core Banks. Dallas Willis has vivid memories of the removals. "I know a lot of people that went to their grave regretting the fact that those horses were taken off of the Outer Banks," he laments. "Because it was a way of life. . . . It wasn't something that just started in the '30s or '40s. It was done right on back. It goes back generation after generation."[17] Wilson Davis also expressed strong feelings. "They were the horses we rode as children," he recalled, "and the horses our children rode. They were transportation when we didn't have a car, and plow horses when we didn't have a tractor. They owe us nothing; we owe them."[18]

Some of the tradition was salvaged in 1957, when a special plea by local residents before the Conservation and Development Committee of the North Carolina General Assembly won a reprieve for the horses on Shackleford. Saved by a group that included Dan Yeomans, 79 years old at the time, and Clarence Willis, both of Harkers Island,[19] the Shackleford horses stand today as a slender vestige of the thousands that once ranged all along North Carolina's barrier islands.

Ironically, the 1933 hurricane that drowned so many Outer Banks horses may have contributed indirectly to the preservation of those on Shackleford. When the storm separated Shackleford Banks from Core Banks, it created a safe haven for a herd that was thus confined to an island that—unlike Hatteras—would not attract the attention of developers or come under the jurisdiction of the National

Ocracoke Scout Dale Burrus and Apache, 1956

Park Service for another 50 years. Following World War II, the Shackleford herd continued under the watchful eyes of mainlanders, particularly Harkers Island residents whose ancestors once lived on Shackleford. Those residents included men like Claude Brown, Weldon Willis, and David Yeomans, who branded and cared for the horses in annual roundups. They tamed and rode some horses. Dallas Willis recalls one method of "breaking" a horse: "Daddy always had a theory about handling horses and stuff like that. He said the less you have to do, the better the horse is and the better off you are. He would take a horse that had never been handled. We'd carry it to the creek, wade it out to its belly in the water. I would get on it, and most of the time I would ride it home. It was just that simple. He couldn't get his head down, he couldn't buck. If he shoved his head down, he was under water, and by the time we wore him down riding him in the water . . . it was harder for him to maneuver. . . . He was calm enough to where we'd come right on up the creek road

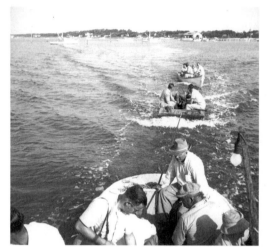

A group sets out from Harkers Island to Cape Lookout and Shackleford Banks for the roundup. Here, a barge and a skiff are being towed by a Core Sound sink-netter. One photographer appears in the left foreground, and possibly two more are seated in the barge.
COURTESY OF NORTH CAROLINA STATE ARCHIVES

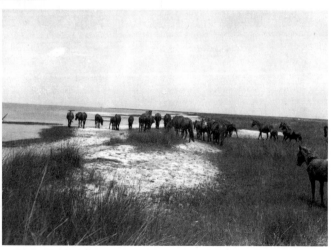

On Shackleford, a large group of horses is being "walked" toward the pen.
COURTESY OF NORTH CAROLINA STATE ARCHIVES

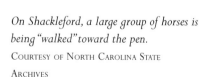

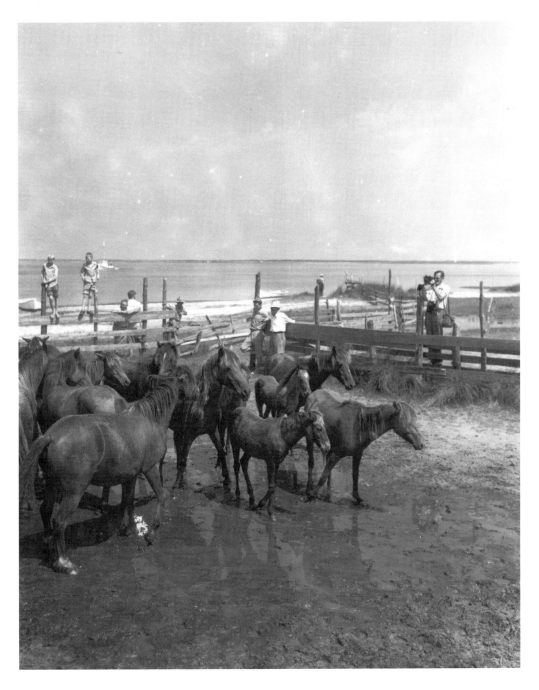

Penned horses await selection for care or branding. On the fence is Aycock Brown photographing the horses with a hand-held camera.

Courtesy of North Carolina State Archives

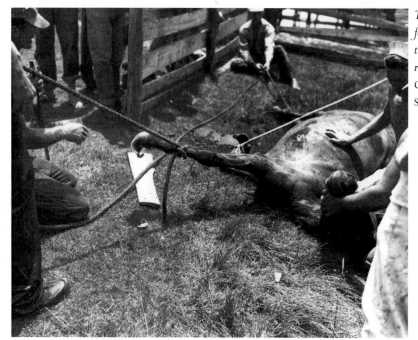

The horn on this horse's foot shows severe overgrowth that, if not corrected, could result in lameness.
COURTESY OF NORTH CAROLINA STATE ARCHIVES

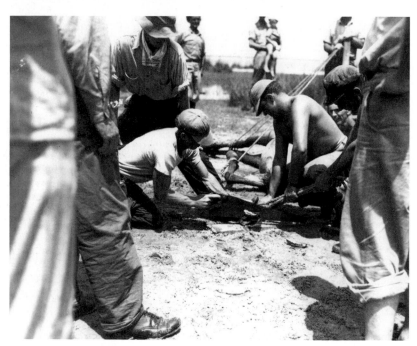

Here, a crosscut handsaw is used to remove most of the overgrowth. A file would then be used to trim the hoof and complete the pedicure.
COURTESY OF NORTH CAROLINA STATE ARCHIVES

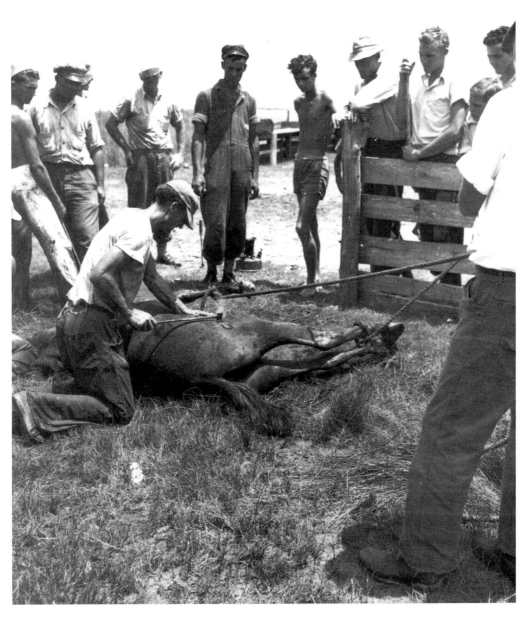

Claude Brown is shown branding his initials onto the rump of a horse. The relatively large size of the animal suggests that roundup and branding had not occurred for some time. It is possible that roundups were suspended during the war, since many of the wranglers would have been in the service.
COURTESY OF NORTH CAROLINA STATE ARCHIVES

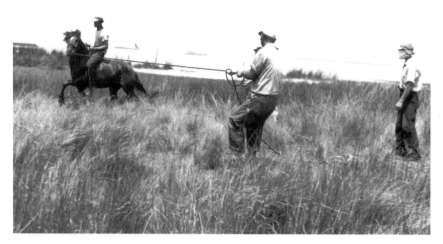

Selected for breaking, this horse is being ridden for the first time. For some reason, the individual standing on the right has a cloth covering his face.

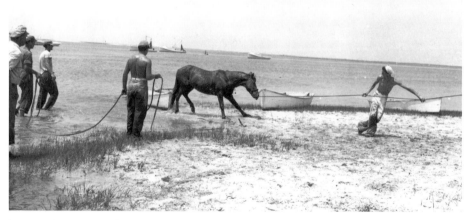

A young horse selected for removal to the mainland resists capture. The trousers of the individual wearing the sailor's cap appear to be covered with the oil from sunken freighters that was still coating the sands and sounds of the Down East region in the summer of 1946.

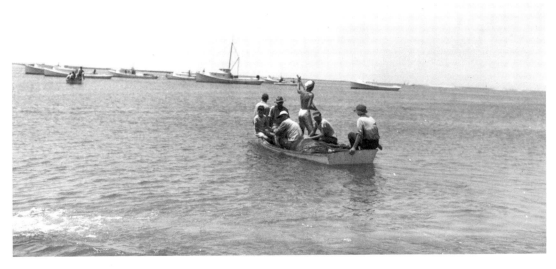

Finally subdued, the young horse lies in a skiff that is also carrying seven men. The skiff is being poled out to one of the sink-netters, which would then tow it to Harkers Island.

Courtesy of North Carolina State Archives

and bring him home, and from then on, he was considered a broke horse."[20] Local tradition maintains that this method of breaking a horse for riding would protect both horse and rider from injury, and that it was learned from Native Americans.

Lifelong Harkers Island resident Joel Hancock recalls times in the 1950s when his older brothers captured and then transported wild horses to Harkers Island for the summer. "One of the saddest days of the year," he writes, "was always the day that our summer pony had to be loaded into a skiff and taken back to the Banks. I can vividly recall how, as we reached the Banks shore, the horse always would hesitate for a moment as the rope was removed from around its neck. Then my father would slap it on its rump, and the pony would gallop away into the thickets and be-

yond the hills. Usually, a few weeks later, we boys would go back and try to find it once again. By then it would be running with its herd. We would call its name, and again it would hesitate for a moment, but only for a moment. For by then it was a 'wild' banks pony once more, and the pull of the herd always proved stronger than the fleeting friendships of a summer across the Sound."[21]

At first, the Shackleford roundups were primarily male activities, but starting in the 1950s, they came to be family events, often occurring as the high point of Fourth of July celebrations. Many Down East residents still remember the roundups as occasions for family and community gatherings that were much anticipated and—when the time came—painful to relinquish.

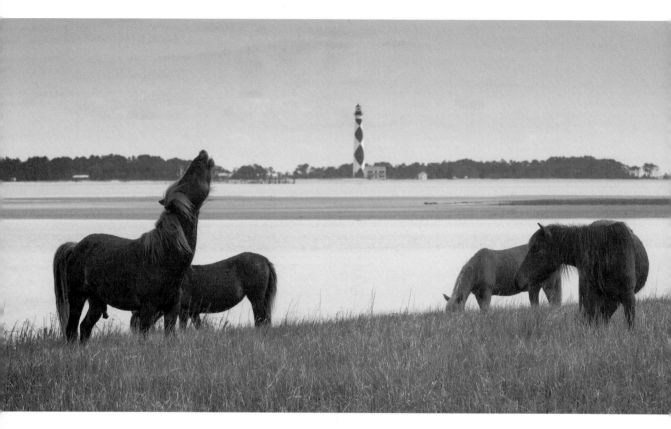

Teddy and his Shackleford harem with Barden Inlet (the "drain") and Cape Lookout Lighthouse in the background

On March 10, 1966, more than 70 North Carolinians and at least that many conservationists assembled in the East Room of the White House to witness President Lyndon Johnson's signing of Public Law 89-366, the legislation that created Cape Lookout National Seashore. President Johnson was particularly proud of this law. It would add a significant link to the "necklace" of national seashores he and his secretary of the interior, Stuart L. Udall, envisioned as running from Cape Cod, Massachusetts, to Padre Island in Johnson's home state of Texas.

The gathering heard the president proclaim that he wanted to be "judged as we judge the great conservationists of yesterday, as benefactors of our people and as builders of a more beautiful America." The *Raleigh News & Observer* reported that this was the first time in 1966 that the president signed a bill that he specifically requested as part of his Great Society program. "And he was apparently glad to be able to talk about something besides Viet Nam."[1]

Nearly two decades would pass, however, before Cape Lookout National Seashore was completely established. Disputes over land acquisitions and management plans delayed for years the dream of a "Bicentennial" seashore park comprising some 60 miles of pristine ocean shoreline from Portsmouth Island in the north to Core Banks and Shackleford Banks in the south, and back again along another 60 miles of sound-side marshland.[2] Planners initially intended to build a bridge between Shackleford Banks and the mainland and to develop the island for tourism, but by the time the legislation was signed, the impetus was strong for the entire park to be designated as wilderness.[3] This meant that all traces of human activity, including motor vehicles, would be "substantially absent" and that structures deemed inconsistent with the natural environment in its undeveloped state

would eventually have to be removed. It also mandated the removal of animals not indigenous to the area, meaning the sheep, goats, cattle, and horses—the so-called exotic species—that had been allowed to roam freely on Shackleford for many years.

Well before officials presented a draft of their park management plan, however, they determined that an exception to the exotic-species policy would be made for the feral horses that lived on Shackleford. In carrying out what they perceived as their responsibility to the nation's citizens, park officials were not always as responsive to local sentiment as many Down Easters would have liked. In the case of the horses, however, it is clear that planners recognized from the start that they would have to be flexible. In a memorandum attached to a draft of the park's first management plan, Superintendent Preston "Mack" Riddel wrote to his regional director, "As noted in our comments in the previous draft, please do not state that domestic livestock *will* be removed! We anticipate that most will be removed; however, there may be some question about the horses." The date of Riddel's memorandum was February 15, 1980.[4]

At the same time that Riddel and his staff were considering exempting the Shackleford horses from the National Park Service's exotic-species policy, a team of biologists from Clemson University was undertaking a study of the effects of animal grazing on the plant life of Shackleford Banks. While the team determined that the horses, sheep, goats, and cattle all ate some of the same vegetation, they did so in significantly different quantities. *Spartina* grasses (salt-marsh cordgrass and up-land grasses), for example, comprised 50 percent of the horses' diet but only 9 percent of the goats'. On the other hand, the woody leaves growing on the edge of the maritime forest made up 56 percent of the goats' annual diet but only 4 percent of the horses'. Moreover, those quantities varied seasonally. This information countered the misconception that, left to themselves, free-roaming Banker horses would eat all the vegetation in sight and completely denude barrier islands of the plant life vital to their continued existence. In addition, since forest growth provided only a minimal part of the diet of the horses (and only of those horses that grazed on the western portion of the island), the horses' effect on the maritime forest was negligible.

The Clemson scientists determined that the greatest adverse effect of horse grazing appeared in the salt marshes, where feeding on *Spartina* cordgrass occurred. In those areas, *Spartina* is the climax vegetation, meaning that when it is removed, there is no other vegetation that takes over and alters the natural balance. "In addition," the Clemson team asserted, "these sites are replenished with water and nutrients with each tide; therefore, major deterioration in site potential to support vegetative growth is unlikely."[5] Thus, the study concluded that continued horse grazing would not unduly affect Shackleford's marshland ecology, at least if the horse population remained stable. Of course, there was no telling what effect storms would have on that ecology, nor could anyone predict the ecological consequences of feeding a higher number of horses.

During the Clemson study, the popula-

tions of the grazing animals on Shackleford were 108 horses, 89 cattle, 144 sheep, and 121 goats. Once the study was completed, park officials proceeded in 1987 with a management plan that included the following statement: "There has been domestic livestock grazing on Shackleford Banks since the 18th century. Even when the State of North Carolina outlawed grazing of livestock on the outer banks (1958) they exempted Shackleford Banks. In accordance with the Park's General Management Plan, cows, sheep and goats will be removed, but because of their potentially historic origin, a 'representative' herd of horses will remain on Shackleford."[6]

The statement called for further study of the island's carrying capacity—that is, its ability to support the horses, as well as the horses' impact on vegetation and their population dynamics. But it is clear that park personnel had already made significant de facto adjustments to their working principle: "Maintenance and management of these horses is contrary to one of the basic precepts of National Park Service policy."[7] In short, while park officials stated in their written pronouncements that keeping horses on Shackleford was inconsistent with national policy, they intended in practice to take a more pragmatic approach.

Over a period of weeks in the spring of 1986, Shackleford's goats, sheep, and cattle were removed. For the first time in at least 300 years, there were neither humans nor domesticated livestock on the island. The wild horses had Shackleford Banks entirely to themselves. Even the Clemson scientists could not predict what would happen next, but just about everyone with an interest in the island

and the horses was watching. They learned what Columbus and the Spanish had discovered in the 1500s. They saw what a dozen generations of Bankers had witnessed when, left to themselves, feral horses roamed the Outer Banks by the hundreds and then thousands. In the eight years between 1986 and 1994, everyone saw what horses do when they are left alone, especially at temperate latitudes in the New World: They thrive like they belong there.

From the 1970s to 1986, the horse population was relatively stable at approximately 100. The shock came with a report on Shackleford's horse population prepared for the National Park Service by Professor Dan Rubenstein of Princeton University. The report indicated that from 1987 to 1994—after the other livestock had been removed—the horse population more than doubled, to 221. It is now generally acknowledged that the figure of 221 was high. Taking an accurate census of wild animals, especially those like the Shackleford horses that move freely through maritime forest, is particularly challenging. Even so, it was clear that the horse population had increased by a very large number. In an interview with *Coastwatch* magazine, Cape Lookout park ranger Chuck Harris articulated the misgivings of all park personnel when he said, "My personal opinion is that this . . . can be a management problem for us."[8]

Subsequently, in January 1996, the National Park Service released its own report stating that, along with the increase in horses, there was an accompanying "increase in the negative effects to the park's natural resources and processes."[9] While the report did not specify what the negative effects actually were,

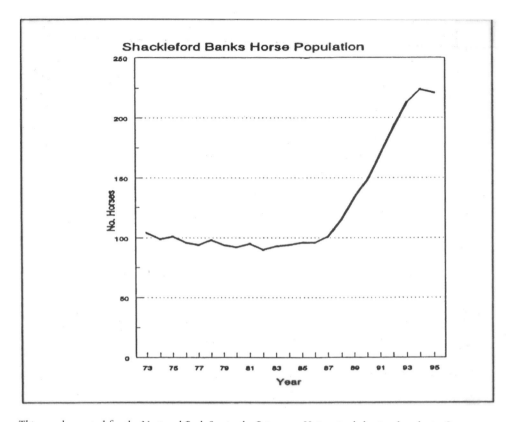

Shackleford Banks Horse Population

This graph, created for the National Park Service by Princeton University behavioral ecologist Dan Rubenstein, shows that the horse population on Shackleford Banks grew from 100 in 1975 to 221 in 1994. The report accompanying the graph notes that the growth rate had shown evidence of slowing in the latest two-year period. The slowdown was attributed to an increase in the number of males and a subsequent increase in sexual "harassment" of females. As harassment increased, grazing time decreased, which resulted in lower fecundity for female horses.

It is now generally acknowledged that the population number was too high. The over-calculation was due to the difficulties encountered in any effort to tally free-roaming animals. Even aerial census-taking of Shackleford's horse population is complicated by the animals' tendency to move freely into and out of the dense maritime forest on the west end of the island.

it noted concern that the horse population "may reach starvation levels."[10] Having earlier cited an obligation to manage populations of non-native animals and plants "up to and including eradication,"[11] the report indicated that the park would develop and implement a horse management plan. To frame the discussion, it outlined four possibilities. At one end of the spectrum was the option of taking no action, which would allow the horse population to grow until the island's carrying capacity was exceeded and horses died from starvation and disease. At the other end was the option of a one-time roundup and sterilization of the

horses, which would then die off altogether in 20 to 25 years.

The "preferred" alternative (and the one that was eventually adopted) fell between the extremes—a one-time roundup, followed by testing, removal, and then adoption of approximately 120 horses. The remaining animals would be allowed to stay on the island. Through a program of immunocontraception, a herd of 50 to 60 horses would be sustained.

The plan was made public in draft form several months before it was accepted. While it generated intense and vocal criticism, it won approval in some influential places. The *Raleigh News & Observer*, for example, had already accepted the plan in principle by the time it was first released for public review.[12] Later, in a lengthy editorial, the *Carteret County News-Times* acknowledged that opposition came from longstanding distrust of the National Park Service by many local citizens, who were suspicious that the government's real intention was to eventually remove the horses completely. "In their minds," the editorial noted, "everything the Park Service does is suspect and insidious." The paper concluded that the best way to save the horses and "protect our mainland interests" was "to abide by the reasonable Park Service proposal."[13]

Many aspects of the proposed plan were criticized, especially the idea of reducing the herd to 50 mares and 10 stallions. But the element that eventually became the flashpoint for an explosion of popular outrage was not the proposed size of the herd. Nor was it the prospect of rounding up and offering for adoption the majority of horses to mainland homes, upsetting as that was to many longtime residents. Rather, the element of the plan that would drive local horse support groups and the National Park Service to the point of confrontation was this brief statement: "From 25 to 33 % of the captured animals (42 to 56 individuals) may test positive for equine infectious anemia and have to be euthanized."[14] Rounding up horses and putting them up for adoption was one thing; killing them was another matter entirely.

❧❧

Equine infectious anemia, usually abbreviated as EIA, is a potentially deadly insect-borne horse disease. Because it is often transmitted in the blood or bodily fluids of inapparent carriers, EIA is similar in some respects to HIV in humans. Although the disease may eventually kill the animal, a horse can live without symptoms for a long time and may eventually die from other natural causes. But since a horse can transmit the disease even if asymptomatic, government regulations prohibit the transportation of infected animals. Because there is no cure for EIA, infected horses must be strictly quarantined or euthanized. In anticipation of what the National Park Service would do to animals testing positive for EIA, various advocacy groups formed to protect the horses. One of them was the Foundation for Shackleford Horses, Inc., incorporated on August 9, 1996.

The park service proceeded with its management plan. In November 1996, it joined with the North Carolina Department of Agriculture's Veterinary Division and a private contractor to round up and test the Shackleford horses.[15] When the job was completed, 184 horses were identified on the island. Although that total was much lower than

the original estimate of 221, it nonetheless represented a population increase of 84 percent in less than 10 years. According to the park service, the population would still have to be reduced.

Under North Carolina law, any animal testing positive for EIA has to be quarantined for 60 days and then retested. A second positive result likely means a death sentence. Following the roundup, the riveting issue was the outcome of the EIA tests. Although everyone was hoping for the best, even the park service's gloomy prediction of 25 to 33 percent EIA infection proved to be conservative. Of the 184 horses rounded up on November 12, 1996, some 76 tested positive, a devastating rate of 41 percent. While the 108 remaining animals that tested negative were returned to the wild, no one could predict how the removal of nearly half the entire population would affect the makeup of the harems and the social structure of the herd. Moreover, the removal would delete a large number of horses from the herd's gene pool. Finally, some 85 percent of the stallions that led harems tested positive, and there was no way of knowing if the stallions that were returned to the wild would effectively take the place of those that were removed. Some stallions simply are not dominant enough to lead harems. Others may be too young or too old to reproduce.

The EIA virus is transmitted by bites from bloodsucking insects, usually horse flies or deer flies. When an insect that has bitten an infected animal then bites another nearby before the blood from the first horse has dried on the insect's mouth parts, then the second horse may become infected. Since all of the

harems on Shackleford graze relatively close to each other along the nine-mile length of the island, it is perhaps not surprising that so many horses were infected. What is mysterious, however, is the manner in which the virus first arrived on the island.

The closest landmass to Shackleford Banks that contains horses is Carrot Island. In previous years, EIA was discovered among the animals there. Carrot Island is actually a group of islands—Horse Island, Bird Shoal, and Town Marsh—near the town of Beaufort and about one nautical mile from the westernmost point of Shackleford. It is certainly possible that a northwest wind could carry flying insects from Carrot Island to Shackleford. But that same wind would quickly dry—and thereby render harmless—any traces of infected blood on the insects' mouths before they had the chance to locate, land on, and bite host animals. One possibility, difficult to prove but reasonable, is that the virus had been on Shackleford for many years but had simply gone unnoticed. The disease was first identified in France in 1843, then tentatively in the United States in 1888. It may have been introduced long ago by a horse or horses transported from the mainland to graze on Shackleford.

However the EIA virus came to be on Shackleford, the grim fact remained that 76 horses either were infected or, in the case of foals with infected mothers, had the potential to become carriers. (Most foals do not contract EIA in utero. It is the proximity of young horses to their dams that increases the likelihood of transmission by insect bites.[16]) All of the carriers were considered to be *inapparent*, the most asymptomatic of the three forms of

the disease and the form that allows quarantine as an alternative to euthanasia. The other two forms are *chronic* (semi-contagious) and *acute* (highly contagious). "In general the chances of transmission from an inapparent carrier are lower than from a horse with clinical signs of EIA,"[17] according to Sue Stuska, the horse biologist at Cape Lookout National Seashore.

North Carolina agriculture officials and the National Park Service wasted no time in dealing with the situation. The horses in question were quickly removed to a quarantine facility in Clinton, North Carolina, while the Foundation for Shackleford Horses scrambled to locate a facility where they could be kept permanently. The prospect for maintaining and feeding—twice daily for as long as they lived—even a small herd of animals was daunting. Although doing so for 76 horses was beyond anyone's imaginings, the foundation proceeded to try. After exploring and (for a variety of reasons) rejecting a number of sites, the foundation located a 1,200-acre tract known as Davis Ridge, consisting of an island and adjoining marsh on Core Sound.[18] State officials soon told the foundation that the site was not suitable. But the issue of what to do with the EIA-infected horses had already been resolved in the early hours of November 20, 1996.

On the order of North Carolina agriculture commissioner Jim Graham, and with the support of the North Carolina Horse Council,[19] the 76 horses at the Clinton facility were put down. That number included all the horses that had tested positive and one foal that had tested negative but slipped into the herd, probably to remain with its dam.[20] During the roundup, two horses had been injured and were euthanized on Shackleford, for a total of 78.

Within hours, the *Carteret County News-Times* published an editorial entitled "Sad but understandable." It called the mass euthanasia "regrettable" and quoted Commissioner Graham as saying, "It was unfortunate that we had to take this step of putting these horses down, but it was in the best interest of the horse industry in the state." The editorialist attempted to console his readers by saying that the 108 horses that remained on the island would ensure their herd's heritage. "If anything good has come of today's decision to euthanize the horses," the paper noted, "it is that awareness of the horses has certainly been heightened."[21]

Protectors of the horses received the news with numbing shock that quickly grew to an anger that had not been seen since December 1985, when, in response to the National Park Service's demand that Banker cottages be removed from Shackleford, the park service's own headquarters on Harkers Island was destroyed by a fire that was intentionally set.[22] Despite the seismic outrage caused by the euthanasia, community response was not violent. But the killing of the horses, the loading of their carcasses into dumpsters, and their unceremonious burial in a county landfill struck even casual observers as acts of staggering insensitivity both to the horses and to the heritage they represented. The events of November 20, 1996, fired a determination that would soon rock the bureaucratic foundation of the National Park Service.

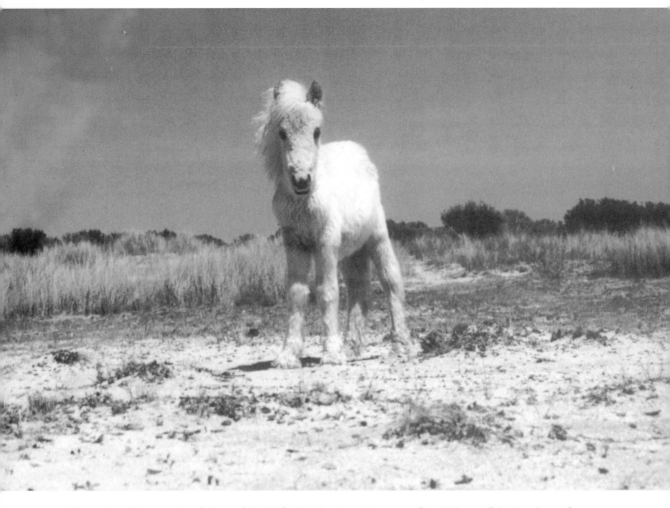

This is the well-known shot of Spirit of Shackleford Banks. An early version of the Web site of the Foundation for Shackleford Horses, composed by Carolyn Mason, included the following from "Spirit's Page":

"*Over two years old, he was barely three feet tall when I first met him. Small as he was, this tiny white horse touched the hearts of a nation. The most powerful and influential personages in our nation's capitol were enthralled, and smiled at the photograph of 'Spirit' of Shackleford. He gave the members of the Foundation the love, compassion, courage and determination to stand between his kind and the threats to their existence.*

"*On January 2, 1997, we found his remains, along with the body of a young mare whose company he had kept since the roundup in November of 1996. His death was the result of human interference; probably well meant, but nonetheless devastating.*"

Because there were no external signs indicating the cause of death, observers believed that Spirit and the young mare may have died from an inability to digest the processed animal feed that someone had given them.
COURTESY OF THE FOUNDATION FOR SHACKLEFORD HORSES

"We do not want Congress telling us we must manage the horses."

<div align="center">

Cape Lookout National Seashore
Superintendent Preston "Mack" Riddel (1983)

</div>

Of all the horses that have grazed on Shackleford Banks, none has come to be more widely recognized or honored than a white colt that was given the name Spirit by Mary Ann Harris's second-grade class at Atlantic Elementary School. Orphaned in March 1996, Spirit became the poster colt of the wild-horse preservation movement and an inspiration for the Foundation for Shackleford Horses. On an early version of the foundation's Web site, Carolyn Mason told Spirit's story: "Over two years old, he was barely three feet tall when I first met him. Small as he was, this tiny white horse touched the hearts of a nation. The most powerful and influential personages in our nation's capitol were enthralled, and smiled at the photograph of 'Spirit' of Shackleford."

The personages to whom Mason referred included the members of the House of Representatives Subcommittee on National Parks and Public Lands. On April 10, 1997, four months after Spirit was found dead along with the young mare that had become his companion,[1] the committee heard from a number of individuals with varying perspectives on the Shackleford horses. They were in the Capitol to express their views on H.R. 765, a bill to ensure maintenance of a herd of wild horses in Cape Lookout National Seashore.

Known as the "Shackleford Banks Wild Horses Protection Act," H.R. 765 was introduced in the House by Congressman Walter B. Jones, Jr., representing North Carolina's Third District. Jones's first recollection of seeing the horses came during family visits to the Banks in the early 1950s. Margaret W. Willis and others therefore found him an enthusiastic listener when they called and reported that they were having a problem with the horses.[2] When meetings between Jones and William Harris, the Cape Lookout superintendent at the time, proved unsatisfactory, Jones and his staff agreed that legislative protection was necessary to save the horses. The bill that Jones sub-

Representative Walter B. Jones, Jr., of North Carolina's Third Congressional District and the poster of Spirit that "touched the hearts of a nation"
COURTESY OF WALTER B. JONES, JR.

sequently proposed required that a herd of between 100 and 110 horses be allowed to roam freely on Shackleford Banks. It also required the secretary of the interior, as head of the National Park Service, to enter into an agreement with the Foundation for Shackleford Horses (or another "qualified nonprofit entity") to jointly manage the herd.

Public-private partnerships are not uncommon in some national parks, but such an arrangement at Cape Lookout National Seashore was opposed by the National Park Service as a "disturbing precedent."[3] Maureen Finnerty, associate director for park operations and education, presented the park service's view to the congressional subcommittee, in-

dicating that her agency strongly opposed the legislation. She asserted that even if H.R. 765 passed Congress, the park service was confident that it would be vetoed by President Bill Clinton,[4] since it would "lead to legislation being proposed each time a [park] management decision is questioned."[5] It is important to note that the park service was not opposed to maintaining a small herd of horses on Shackleford but wanted to do so without public interference or congressional mandate. Years earlier, when attempting to develop an acceptable management plan for Cape Lookout National Seashore, Superintendent Riddel had written to his regional director, "We certainly do not see anything positive in legisla-

This photograph shows the gentle way in which horses are walked to the pen in the now-infrequent roundups coordinated by teams from Cape Lookout National Seashore and the Foundation for Shackleford Horses. Since horses living on the western end of Shackleford must be moved five or six miles eastward to the pen, it is essential that they not be physically exhausted or unnecessarily stressed. The best means for carrying out such an objective is simply to coax them in the proper direction.

tive language that would mandate us to manage feral horses on Shackleford Banks as wildlife." He added, almost prophetically, "We do not want Congress telling us we must manage the horses."[6] In 1997, several years after Riddel retired from the park service, his management fears had come to pass.

Many residents of the area were skeptical of the park service's willingness to maintain the herd over a long period of time, so they rallied around the Jones legislation as the only sure way to keep horses on Shackleford. Tom Bennett, Jr., appeared before the subcommittee as chairman of the Carteret County Tourism Development Bureau. His testimony was unapologetically mercenary. He was in Washington to show the importance of the horses to Carteret County's number-one industry—tourism. One of the top three most-asked questions at the county's two visitor centers, Bennett asserted, was "How can we get to see the horses on Shackleford Banks?"

Margaret W. Willis's testimony was more scientific and culturally anchored. The director of the Foundation for Shackleford Horses, Willis cited the assessment of Jay F. Kirkpatrick, director of science and conservation biology at ZooMontana. Kirkpatrick wrote that, since wild horses are naturally selected for survival under conditions that would be fatal to most domesticated animals, the Shackleford horses provided "collections of genes that may be a valuable resource for domestic horses in the future."[7] Willis concluded that the Shackleford horses are a living cultural resource and an "irreplaceable part of our national heritage."

Congressman Jones also spoke in favor of his legislation. To ensure that he had the attention of everyone in the committee chamber, he displayed a 20-by-30-inch color poster of Spirit, the colt that, Carolyn Mason later declared, inspired the foundation "to stand between his kind and the threats to their existence."[8]

Support for H.R. 765 in the House of Representatives was overwhelming. On July 22, 1997, the bill passed by a vote of 416 to six. By the time that it came to the Senate on October 1, 1997, it had the support of both North Carolina senators, Jesse Helms and Lauch Faircloth. North Carolina governor James B. Hunt also supported the measure. In a letter to Congressman Jones, he wrote, "These horses are truly a treasure for our state's citizens, as well as tourists . . . and I feel it is important that this cultural resource be maintained for the future."[9]

The measure won the endorsement of another influential North Carolina native, Erskine Bowles. At the time, Bowles was the White House chief of staff. Although he did not know Bowles personally, Jones called him when it was clear that the Department of the Interior intended to oppose H.R. 765. Congressman Jones recalled Bowles saying, " 'I remember going down [to the coast] as a child and seeing those horses. My children, . . . *they* saw the horses.' And he said, 'Walter, I'd like to help you.' " Later, after the Jones legislation was passed by the House, Bowles indicated that if H.R. 765 were approved in the Senate, President Clinton would sign it. "That really was a big help," Jones remembered. "[Erskine Bowles] really helped me with the [Clinton] administration."

Apparently recognizing how the currents of politics and popular sentiment were commingling in favor of H.R. 765, the National Park Service announced a surprising turnabout. When Maureen Finnerty presented her Senate testimony on October 1, 1997, she indicated that the National Park Service now supported enactment of H.R. 765, though it offered two modifications—namely, that the requirement for a specific herd level be removed and that any adverse impact the horses might have on the island's natural resources be considered.

The resolution was approved by the Senate on July 17, 1998. Subsequently, on August 13, it became Public Law 105-229, bearing the signatures of Georgia congressman Newt Gingrich, speaker of the House of Representatives; South Carolina senator Strom Thurmond, president of the Senate *pro tempore*; and William J. Clinton, president of the United States. Within a period of two years, a small group of private citizens inspired by a

feisty band of wild horses had made history with an act of Congress.

The story of the Foundation for Shackleford Horses and P.L. 105-229 is a dramatic example of how a variety of factors converged over the welfare of the Shackleford herd. North Carolina politicians played a predictable but remarkably nonpartisan role. Congressman Jones is a Republican, but he was supported early on by North Carolina state senator (now lieutenant governor) Beverly Purdue, a Democrat. Former senators Helms and Faircloth are Republicans, but former governor Jim Hunt and Erskine Bowles are Democrats. With the weight of voters behind H.R. 765, the support of North Carolina's politicians of every rank and stripe was not surprising. But there is far more to the story than politics.

The park service's attitude toward the horses was seen by many as, at best, a disregard for one of the most cherished aspects of their heritage. Even before the galvanizing event of November 20, 1996, when the Shackleford horses were put down, local citizens perceived the park service's management proposals as nothing less than an attack on freedom—or at least what is for them an icon of American freedom, the wild horse. Rallying on the lawn of the Carteret County Courthouse in March 1996, Jerry Hyatt spoke for a group called We the People. Hyatt announced that the purpose of the rally was to declare opposition to the National Park Service's plan to reduce and manage the Shackleford herd. He was there to educate and encourage those who loved the "idea" of the Shackleford horses, which, he asserted, "have run wild for 400 years [and should] continue to have that freedom." Another speaker, Sandy Salter, read a poem citing the free movement of the horses as their own form of liberty and asking if people were entitled to take that freedom after so many hundreds of years.[10]

No one on the Beaufort courthouse lawn could have predicted what would unfold over the next two years. Fired up as they were, none in the crowd foresaw the legislation that would come from the relentless efforts of a few individuals with access to the Internet, with creativity, and with a determination swayed neither by inexperience nor by fear of the massive weight and resources of a federal bureaucracy. The *Carteret County News-Times* summed it up, declaring that the Shackleford Banks "pony war" showed that "a determined people with a righteous cause can fight city hall, or in this case Uncle Sam, and win." And that, the paper concluded, "is what democracy is all about."[11]

Several years later, former Cape Lookout superintendent Karren C. Brown echoed that sentiment. "When you think about it literally," she wrote, "a handful of people interested in preserving the horse herd and standing up to the government managed to have legislation passed protecting these wild horses forever. Pretty amazing stuff, the very thing that makes America great."[12]

One Hundred Fifth Congress
of the
United States of America

AT THE SECOND SESSION

Begun and held at the City of Washington on Tuesday,
the twenty-seventh day of January, one thousand nine hundred and ninety-eight

An Act

To ensure maintenance of a herd of wild horses in Cape Lookout National Seashore.

Be it enacted by the Senate and House of Representatives of
the United States of America in Congress assembled,

SECTION 1. MAINTENANCE OF WILD HORSES IN CAPE LOOKOUT NATIONAL SEASHORE.

Section 5 of the Act entitled "An Act to provide for the establishment of the Cape Lookout National Seashore in the State of North Carolina, and for other purposes", approved March 10, 1966 (Public Law 89–366; 16 U.S.C. 459g–4), is amended by inserting "(a)" after "Sec. 5.", and by adding at the end the following new subsection:

"(b)(1) The Secretary, in accordance with this subsection, shall allow a herd of 100 free roaming horses in Cape Lookout National Seashore (hereinafter referred to as the 'Seashore'): *Provided*, That nothing in this section shall be construed to preclude the Secretary from implementing or enforcing the provisions of paragraph (3).

"(2) Within 180 days after enactment of this subsection, the Secretary shall enter into an agreement with the Foundation for Shackleford Horses (a nonprofit corporation established under the laws of the State of North Carolina), or another qualified nonprofit entity, to provide for management of free roaming horses in the seashore. The agreement shall—

"(A) provide for cost-effective management of the horses while ensuring that natural resources within the seashore are not adversely impacted; and

"(B) allow the authorized entity to adopt any of those horses that the Secretary removes from the seashore.

"(3) The Secretary shall not remove, assist in, or permit the removal of any free roaming horses from Federal lands within the boundaries of the seashore—

"(A) unless the entity with whom the Secretary has entered into the agreement under paragraph (2), following notice and a 90-day response period, fails to meet the terms and conditions of the agreement; or

"(B) unless the number of free roaming horses on Federal lands within Cape Lookout National Seashore exceeds 110; or

"(C) except in the case of an emergency, or to protect public health and safety.

"(4) The Secretary shall annually monitor, assess, and make available to the public findings regarding the population, structure, and health of the free roaming horses in the national seashore.

"(5) Nothing in this subsection shall be construed to require the Secretary to replace horses or otherwise increase the number of horses within the boundaries of the seashore where the herd numbers fall below 100 as a result of natural causes, including, but not limited to, disease or natural disasters.

"(6) Nothing in this subsection shall be construed as creating liability for the United States for any damages caused by the free roaming horses to property located inside or outside the boundaries of the seashore.".

Speaker of the House of Representatives.

~~*Vice President of the United States and*~~
President of the Senate pro tempore.

APPROVED

AUG 1 3 1998

H.R. 765, popularly known as the Shackleford Banks Wild Horses Protection Act, was signed by Newt Gingrich, Strom Thurmond, and President Clinton. It begins, "An Act to ensure maintenance of a herd of wild horses . . ."

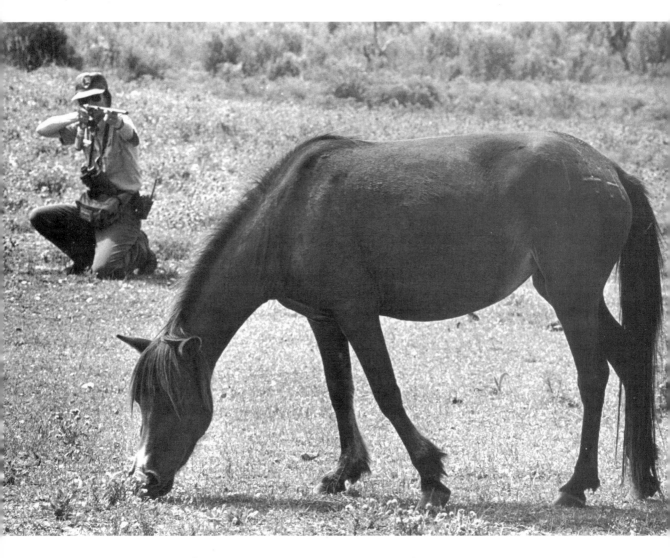

Park Ranger and wildlife biologist Sue Stuska demonstrates the process of injecting the PZP vaccine. In this instance, the dart was not fired. Had this been an actual procedure, it could have taken two to three hours. "I spend a lot of time standing around," Dr. Stuska says. Wind direction and speed have to be taken into account. Angle of shot is important, too, the preference being to penetrate at an upward angle, so the dart might more readily fall out after the vaccine has been delivered. Taking one's time is necessary "so that the mares become accustomed to my presence," Dr. Stuska adds. "I try to shoot from behind a tree or from behind another animal, so that they don't associate the dart with the gun. This would create unnecessary stress on the horse."

Since the signing of the Shackleford Banks Wild Horses Protection Act in 1998, the National Park Service and the Foundation for Shackleford Horses have successfully teamed up to carry out an effective management plan for the horses. Moreover, the debate over the horses' origins has shifted largely from the historical to the scientific arena. While popular tradition holds that the Shackleford horses descended from animals bred on colonial Spanish haciendas, there have always been skeptics who saw the horses' ancestors as domesticated castoffs abandoned to fend for themselves after their owners were driven off the Banks by the storms of the 19th century. Writing in the *American Anthropologist* in 1940, Thornton Chard was among the first to argue that it was "highly improbable" that any Spanish horses introduced to the American Southeast in the 16th century survived long enough to reproduce and leave descendants.[1]

For a long time, the view of the National Park Service was equally skeptical. In 1990, *Park Science* magazine cited a study concluding that none of the feral horses on Georgia's Cumberland Island, North Carolina's Shackleford Banks and Ocracoke Island, and Virginia's Assateague Island possessed any "unique genetic material" that would indicate a line of descent from 16th-century Spanish horses. Further, the article noted that the horses on Shackleford may not have *any* colonial origins and "probably derive primarily from stock brought to the islands after the 1899 hurricane, and may be a mix of Hatteras island animals, Quarter Horses, Tennessee Walkers and other breeds."[2]

In 1997, biologist Dirk Frankenburg asserted in *The Nature of North Carolina's Southern Coast* that the Shackleford herd was not established on the island until the 1940s, apparently confusing it with the horses on Carrot Island that were introduced at that time.[3] Most recently, Bonnie S. Urquhart has written that because human settlements were successful on Shackleford Banks and Core Banks for many decades, it is probable in her view "that most, if not all, of these horses descended

from the livestock turned loose by mainlanders or left behind when the owners resettled on the mainland."[4]

Proponents of traditional lore have been passionate in their efforts to prove that the horses are Spanish (or at least have a significant amount of colonial Spanish blood) and that they roamed Core Banks and Shackleford Banks even before European settlers on Cape Lookout's wind-swept dunes scanned the horizon for supply ships and whales. These proponents have marshaled the sciences of blood typing and genetics to prove in fact what they believe in their hearts. Margaret W. Willis has stated unequivocally, "We cannot and do not assert that the Shackleford horses are 'pure' anything." But she also has declared, "We can make a strong argument for their close similarity to Colonial Spanish stock in phenotype, can relate blood factors that also indicate a similarity in genotype, can relate blood factors indicative of uniqueness, and can point back in history in general events and in specifics that indicate a long term presence."[5] Among the most prominent authorities whom Willis and the Foundation for Shackleford Horses cite in their arguments are D. Phillip Sponenberg, professor of pathology and genetics at the Virginia-Maryland Regional College of Veterinary Medicine, and E. Gus Cothran, former director of the Equine Genetics Laboratory at the University of Kentucky.

According to Sponenberg, identifying blood markers is a matter of "simple genetics."[6] But like the more subjective tools of history and common-sense observation, blood typing is far from foolproof. One problem is that most horse breeding over the last few centuries has involved crossbreeding of different types and styles of horses, and most breeds therefore share many blood markers. Also, many horses fail to pick up blood markers that may be unique to their breed or breed group. A purebred Spanish horse might have an essentially generic blood type, with nothing unique indicating the animal's origin. In such a case, history and external appearance may be more reliable tools for identification.

On the other hand, the opposite situation can occur. According to Sponenberg, there are "many, many markers that point to a Spanish origin, but are shared among many breeds." Sponenberg hypothesizes that it would be possible for a purely Spanish stallion bred to a herd of draft mares to produce, within two generations, a "grade draft horse, probably betraying nothing of its Spanish ancestry in looks or performance but having uniquely Spanish markers in blood type."[7] The result here, judged by blood type alone, would be horses "more Spanish" than the purebred Spanish horse with the generic blood type. Mary Ann Thompson puts it this way: "Depending on how these markers are inherited a horse with no Spanish markers at all could be of heavy Spanish ancestry whereas a horse with a number of Spanish markers could still have a good deal of other blood and could, in actuality, have a great deal less Spanish blood than the horse with no Spanish markers."[8]

The lesson is that, even with the sophisticated technology of blood testing, determining the origin of feral horses is at best an inexact science. "The bottom line," Sponenberg concludes, "is that common sense needs to be used when evaluating horses by any method.

All the tools available will never replace common sense or experience."[9]

For a number of years, Dr. Gus Cothran has been studying the genetics of feral horse populations. The purpose of Cothran's work is not to establish the origins of wild horse herds. Rather, its function is to aid in the management of free-roaming horses and burros so that herds living on public lands can be kept small enough to prevent ecological damage but still maintain the genetic variation needed to ensure their long-term genetic viability.

In November 1996 and March 1997, Cothran collected 142 blood samples from the Shackleford herd. Those samples were subsequently compared to those of 102 domestic horse populations that had been tested at the Equine Blood Typing Research Laboratory. The comparison yielded a remarkable discovery that offered welcome news to horse advocates. Cothran's analysis indicated that genetic variation within the Shackleford herd was "near the average for [other] horse populations."[10] That is, the Shackleford herd revealed no significant inbreeding. Thus, a population of 100 adult horses could sustain itself genetically, barring "catastrophic losses due to natural disasters."[11]

Even more welcome was the report that, genetically, the Shackleford herd most closely resembles "the Welsh Pony followed by the Percheron, Posavina [sic], Chilean Criollo, and Belgian Halfblood breeds."[12] Clearly, the Shackleford horses share genetic elements with a number of other breeds. But Cothran discovered an element that the other breeds do not have, something he calls the "Q-ac variant." Found mainly in modern breeds with Iberian Peninsula origins, the Q-ac variant (or marker) provides "strong evidence for 'old' Spanish blood."[13] Cothran noted that it was not possible to quantify this ancestry or to determine when it was established, but he has so far found it in only two other New World breeds—the Puerto Rican Paso Fino and Wyoming's Pryor Mountain Wild Horse Range herd, *both* of which are believed to have Old World Spanish origins. While stopping short of saying the evidence is conclusive, Cothran asserted that the Q-ac variant led him "to believe that this herd of North Carolina Banker Horses could be descended from a very old core group of Colonial Spanish Horses."[14]

Cothran's discovery and others underscore with scientific evidence what common sense had long ago told horse advocates. In June 1982, representatives from the Spanish Mustang Registry were persuaded to travel from Oshoto, Wyoming, to North Carolina to examine the Shackleford herd. These representatives were Emmett Brislawn, son of the registry's founder, and Cody Holbrook. "At Harkers Island, fisherman Weldon Willis, in white clam boots, ferried Wyoming Mustangers wearing cowboy boots, to Shackleford Banks in his fishing boat,"[15] the *Fayetteville Observer-Times* reported. The visitors closely examined the physical features of some of the Shackleford herd. Subsequently, two Shackleford horses—Mr. Shackleford Banks (#600), a sorrel stallion, and Scotch Bonnet (#704), a sorrel mare—won coveted places on the registry.

It is Cothran's genetic analysis that has so far provided the most promising scientific link between the Shackleford herd and the fabled horses of colonial Spanish extraction.

The Q-ac variant and other relevant markers could well have found their way into the genes of Shackleford's horses long after the Spanish practically relinquished the Land of Ayllón to Sir Walter Raleigh. But the presence of the markers should at least compel skeptics to think again. The National Park Service has already done so. Its latest brochure on the horses (January 2004) now has a section on origins that reads, in part, "Genetic research shows evidence of Spanish ancestry in the Shackleford herd."

❧❧

Even the debate over whether or not the horses should be considered an exotic species has been rendered largely academic. The wars of words and attitudes between historical research and strongly held popular beliefs, between the rightful place of the horses on the Banks as established over time and the widely accepted prohibition of non-native animals from wilderness areas, has now taken second place to the congressional law. The twofold mandate of that law was designed to ensure that a viable herd of 120 to 130 horses remains on Shackleford and that the delicate ecology of the island is maintained.[16]

Ultimately, the passage of the horse preservation bill had less to do with history and politics than with local reverence for the horses as a living legacy. But the success of P.L. 105-229 was also due to the nearly mythic status universally accorded to wild horses by Americans. When bills to protect wild horses in the West were proposed in Congress in the 1970s, it became clear that the wild mustang rivals even the bald eagle as an icon of the American experience. During those hearings, the horses were often described as "symbolic of the rugged independence and tireless energy characteristic of the early growth of the United States from ocean to ocean" and as "living symbols of the historic and pioneer spirit of the West."[17] Thus, what the wild mustangs of the American West and the wild horses of the Outer Banks mean in the minds of those who revere them is often more important than the animals' bloodlines or historical origins.

And they mean many things to many people. In a 1939 case adjudicated by the North Carolina Supreme Court, for example, the wild horses of Ocracoke were used to explain a legal decision. The convoluted case involved allocation of the benefits derived from the successful contestation of a will. The dispute was between two groups of heirs to an estate. One group chose to contest the will, while the other declined to support the action both legally and financially. When the contestation resulted in a financial gain for the former group, the latter group sued for a share in that gain. The case came down to a simple question: Should the group that made no effort to contest the will enjoy the same reward as the group that chose to do so?

In a lower court, a jury said yes. However unreasonable it may appear, the group that chose not to contest the will was still legal heir to the estate. The law was on its side even though it had failed to take the initiative to protect its own financial interest. The North Carolina Supreme Court disagreed, citing the wild horses of Ocracoke to illustrate how the legal concept of equity may be "the tool by which the law is enabled to make a finer adjustment of individual rights consonant with

commendable human conduct." Writing for the majority, Justice J. Seawell noted, "On the barren outer banks of Eastern North Carolina, the race of 'banks ponies' has survived for two hundred years against the forces of nature with little or no help from man. Their tenacity of existence is heroic." Seawell observed that the horses had learned many tricks for surviving, including gathering in groups of three or four and digging for water when they were thirsty. "If a pony who has not assisted in their labors comes up for a free drink, they turn their heels upon him and drive him away. This," he crisply observed, "is equity on Ocracoke."[18] Judge Seawell declared that the trial court's conclusions were not warranted by the facts. In failing to assert their right to contest the will when the opportunity was presented to them, the plaintiffs basically gave up their claim to any additional benefits resulting from the legal efforts of those who took action.

How the plaintiffs responded to being compared to a freeloading horse scrounging for a handout was not recorded. However, the defendants were probably not at all offended by the analogy. It is remarkable that a decision formulated at the highest North Carolina court was illuminated by and—more important—affirmed by Banker horses living according to their own rules in a state of nature. Their instinct for self-preservation and their elemental form of frontier justice illustrate bedrock American values.

When the drive for the passage of H.R. 765 was getting under way, Alexander Kaszas—a refugee from the 1956 Hungarian revolution—wrote to Congressman Jones saying that he raised his children "to love and respect this land that has given me both freedom and life when [they] seemed almost lost." He added, "The [Shackleford] horses, like the American Flag, represent to me a symbol of that freedom."[19]

Other views of the Shackleford horses are less overtly patriotic but just as deeply felt. One magazine writer described them as "the embodiment of the small, tough competitor whose coat may be ragged but whose spirit flies over the sand dunes like the wind."[20] The horses are seen by some as an asset to tourism. Carteret County has not yet caught up with Virginia's Accomack County, where billboard images of wild horses easily outnumber the real animals, but the call to "See the Wild Banker Ponies" becomes more widely apparent with each passing season. Horse geneticists value the herd as a precious and irreplaceable reservoir of "hardiness" genes that may be lost in domestically bred horses or in other herds. In the spring of 2006, two Shackleford colts—Wenzel and Doron—were transported to Ocracoke Island, where they are being bred to select mares to strengthen the gene pool of the Cape Hatteras herd. Behavioral ecologists study the horses for the ways they help the scientific community "expand its understanding of social behavior of mammals in general as well as how to apply biology to issues in conservation."[21] Local historians see the Shackleford horses as a living legacy connecting coastal residents to their ancestors and Americans to our colonial past. Painters like Kim McElroy are drawn to them as living art that reveals to the sensitive observer some of life's most profound and mystical forces.[22]

Above all, what the horses represent to

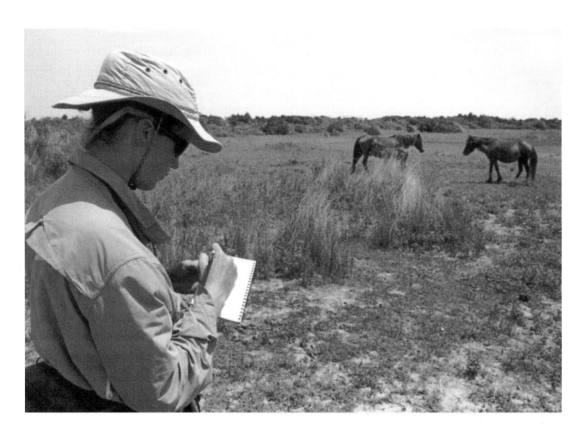

Princeton University students have been actively conducting research on Shackleford Banks since Professor Dan Rubenstein began his work with the horses in the 1970s. Each summer, Rubenstein's students select a theme and name the foals born the previous year. In 2001, for example, they chose cartoon characters such as Heloise. In 2002, the theme was countries and cities, so new foals were named Belize, Brazil, Delphi, Denmark, Djibouti, Dublin, Haiti, Holland, Switzerland, and Zim (for Zimbabwe). In 2003, the students decided on biblical names—Jair, Zack (for Zechariah), Noah, Kenan, Philip, and Shiprah. Foals are typically given names with first letters that match those of their dams, thereby creating identifiable matrilineal groups.

Stephanie Dashiell of Los Angeles, California, was one of three Princeton students who camped on Shackleford during the summer of 2002. She was studying the movements, eating habits, and mating and social interactions of individuals within 10 harems. In addition to her binoculars and notebook, Stephanie's equipment included two watches—one for recording the time of day, the other for measuring "how many bites per step horses took in each of the [island's] habitats." As she described it, Stephanie's plan was "to develop an index of quality for each of the habitats and compare this index with the bites per step data and with the amount of time the groups spend on each habitat to see if they are maximizing the acquisition of resources." The highly technical nature of Dashiell's work, which is just one of many ongoing studies, suggests that the Shackleford horses are one of the world's most closely observed animal populations.

the popular mind is the concept of wildness, a natural lifestyle free from any dependence on humans. The staunchest local defenders of the horses insist that the animals will survive—as they have for hundreds of years—if people will just leave them alone. One of the ironies of the Shackleford Banks Wild Horses Protection Act, however, is that to protect the horses and their island, they cannot be left alone. They are "wild" in only the most superficial way, for the herd's long-term survival is now dependent on something that neither the horses themselves nor nature can provide— that is, the genetic diversity that will guarantee the production of healthy, well-developed individuals. Fortunately, a model for such management existed before the protection act was passed.

≈≈

In conjunction with Jay Kirkpatrick, the National Park Service has been administering a horse immunocontraceptive program in Maryland's Assateague Island National Seashore.[23] Moreover, at Assateague, the scientific toolbox includes not only genetics but space-age technology. In 2001, for example, three government agencies—the United States Geological Survey, the National Park Service, and the National Aeronautics and Space Administration—teamed up to use NASA's Airborne Topographic Mapper, or ATM (a combination of airplane and satellite infrared imaging systems), to photograph and study the ecological effects of grazing by Assateague's 180 wild horses.[24]

Officials of Cape Lookout National Seashore have not yet enlisted NASA's ATM system, but they have created a staff position specifically for Shackleford's horses. Dr. Sue Stuska, Cape Lookout park ranger and wildlife biologist for horses, is responsible for implementing the management plan. She has a formidable array of technological wonders for doing so, including a Garmin 12CX global

The PZP immunocontraception dart is an apt emblem for 21st-century wilderness management.

positioning system (GPS) to record the grazing locations and water holes of Shackleford's various harems. She is also an excellent shot with the Dan-Inject® carbon dioxide pistol-grip blowgun. That instrument shoots a dart that administers just the right dose of the contraceptive vaccine Porcine Zonae Pellucidae (PZP). The objectives are to prevent the birth of foals that would not enhance the herd's gene pool and to encourage noninjected mares to produce an "heir and a spare" that will enhance the pool.[25]

The Shackleford management plan begins with the sacrificing of the horses' anonymous wilderness identities for numbers that are freeze-branded with liquid nitrogen onto the left rump of each animal. This identification is necessary so that the horses' population dynamics can be carefully modulated to create the proper ratio of males to females and to ensure that the mandated population of 120 to 130 individuals is maintained. The PZP injection process that follows is a fascinating combination of art and science. Kirkpatrick and Stuska liken it to a "dance with wild horses," a series of improvisational and unobtrusive movements of the shooter in concert with the movements of the animal. The only thing missing is music. Kirkpatrick describes it this way: "One of the guiding principles is

Since his appointment as superintendent of Cape Lookout National Seashore, Missouri native Robert A. Vogel has continued the work of his predecessor, Superintendent Karren Brown, in bridging the gulf that for many years separated the people of Carteret County from the National Park Service. During the ceremonial transfer of the Cape Lookout Lighthouse from the United States Coast Guard to the National Park Service on June 14, 2003, Vogel articulated the vibrant new relationship that he is helping to forge between his agency and the local population. In his address, he proclaimed, "America's national parks were places of human feeling before they became parks. They are ancestral homelands. People lived and died there. They shared emotional, spiritual, intellectual, and sensual perceptions about the land—its sounds, smell, and feel; its skies, wildlife, plants, and water. We are coming to understand that parks become richer when we see them through the eyes of people whose ancestors once lived there."

Vogel is shown here at the top of the Cape Lookout Lighthouse. Shackleford Banks is in the background.

to behave in such a way that the horse isn't sure you are actually after her. One can lolly gag along, pick up seashells, poke at the water, sit down now and then, look at everything except the horse, and so on. If the horses start walking, you can't follow them, but rather have to walk parallel with them, sometimes for a mile or more. When they are not looking, you can take side steps and narrow the distance between you and them. Other times you simply need to sit down and relax for 20 minutes. Let them watch you for a while and then they will go back to feeding. On rare occasions, if you know your animals well and the situation allows it, you can sit and let them come to you. It actually works once in awhile. What you cannot do is stalk a wild horse successfully. . . . Their senses are just too acute and you will fail every time."[26]

Kirkpatrick also compares the PZP darting process to a football playbook with "a play for almost all situations." "My favorite," he says, "is the 'stallion screen play.' The stallions seem to be far less cautious of you, and some pay very little attention to you. The mares, on the other hand, relax just a bit if the stallion is between you and them. So, I'll approach the stallion from the far side, taking my time and talking to him, and on some occasions, I get within range and have to lean a bit around the stallion's hind end and take my shot. This really surprises and probably annoys the mares."[27]

The results of the PZP program on Shackleford have been encouraging. According to a National Park Service news release, none of the 19 mares contracepted in the field during the spring of 2001 tested pregnant or foaled in 2002. Of the 40 mares contracepted in the spring of 2002, one subsequently conceived and foaled.[28] In addition to the long-term benefits to the herd and to the healthy ecology of Shackleford (because of horse population control), the immunocontraception program has a direct benefit for the mares themselves—increased life span. The mares that receive birth-control-induced rest periods live longer than those that produce foals at every opportunity.

Everyone closely associated with the horses accepts this technological sleight of hand as necessary to ensure that the structure of the herd on Shackleford will represent that of "a natural population [and] maintain natural population dynamics, including genetic diversity."[29] Of course, the prospect of continued (and indefinite) manipulation of wild horses at the genetic level reduces the idea of wildness to an elaborate illusion. It forces upon us the concept of "wilderness management," an oxymoron spawned by the convergence on Shackleford Banks of science, politics, history, and popular sentiment. Not all observers are entirely pleased with the way things are working out, but the horses are thriving and the island's ecology is holding its own. Moreover, the enmity that once existed between the National Park Service and many local citizens has all but disappeared, thanks in large measure to the good-faith efforts of dedicated people on both sides. And whatever disagreements may arise over the horses' origins or future management, no one doubts that they will continue to have an irresistible hold on nearly everyone who sees or imagines them.

❧❧

Foundation for Shackleford Horses Board of Directors member Margaret Fondry and Shackleford horses on the mainland

Since 2000, the Foundation for Shackleford Horses has run an adoption program as part of its role in teaming up with the National Park Service to manage the Shackleford horse population. So far, some 56 horses have been carefully matched with families on the mainland. While most have found homes in North Carolina, others have traveled to more distant locales—Miss Mabel, Brazil, and Honduras live in Elizabethton, Tennessee, and Tupper went to Oxford, Georgia. Ten Shackleford horses live with a wild herd on Cedar Island, North Carolina, where seven foals—Worth, Jessie, Poppa Al, Ronald, Ulva, Perry, and Katherine—have been born and subsequently named for elderly or deceased Cedar Island human residents. Eight horses that tested positive for EIA—five in 1997 and three in 1998—enjoy lives of quiet and apparently healthy seclusion. Quarantined for life in an undisclosed Down East location, they are cared for twice daily by foundation volunteers.[1] Fortunately, no Shackleford horses have tested positive since the three were removed in 1998. Although a few young horses are removed from the island each year as needed, the 2005 roundup was probably the last in the foreseeable future.

Adopted wild horses and their owners seem to enjoy special relationships, different from those of domesticated horses and their owners. Like other horses, they have the capacity to become playful, loving pets. But unlike their domesticated brethren, Shackleford's horses have a nature and a heritage that set them apart—wherever they are—as ambassadors of wildness. For some owners, their Shackleford horse provides a historical connection with the past. "My ancestors had Banker ponies as farm horses," says Jamie Gillikin-Hibbs, owner of Leo, who was moved from Shackleford in 2001. Using a bit of Down

Susan Goines and Angel

Paul Henry and Heloise

In 2004, when he was only a few days old, this colt was rescued from drowning after being separated from his mother by an unleashed dog brought to Shackleford by visitors. He was removed from the island to be treated for an eye infection and is shown here on the mainland with Hailey Elizabeth Pearsall, Carolyn Mason's granddaughter. Named Diego, the colt was adopted in 2005 by Jennifer Windham, a veterinary student. He now lives in Coates, North Carolina.

East vernacular, as if talking about a family member, she adds, "Leo's used to me mommicking [teasing] him—treating him like a baby."[2] Others, like veterinarian's assistant Penny Wright, value the historical connection. "We have a piece of the Banks heritage here," she says, referring to Sam. In addition, Sam has "special needs," and "that's why we chose to adopt him."[3] Describing Heloise, a young mare born on Shackleford in 2000 and adopted the following year, Le Ann Henry, an elementary-school teacher, insists, "If anyone says you can take a Shackleford horse and make it behave like a domestic horse, it's not true!

They're too smart. I've been around horses all my life, and Heloise is the smartest I've ever seen."[4] Others agree. Because the Shackleford horses have not lived except in the wild, they tend to be curious about everything. Though often shy, they are not fainthearted. "Angel's like an innocent baby who doesn't know anything bad about people," says Susan Goines, a nurse. "He doesn't have any fear. He just wants to play."[5]

It is hard to say exactly why the wild Banker horses elicit such profound feelings. Perhaps they touch us so powerfully because, as creatures on their own treading upon the sandy pastures that separate a vast continent from a limitless ocean, their story is an affirmation of the American experience. Just *seeing* them grazing in the dunes or galloping through the marshes reconnects us with something elemental. Would it be going too far to assert that these horses and other wilderness creatures are a vital part of our well-being as a nation? The reintroduction of red wolves in eastern North Carolina and of radio-collared (and numbered) elk in the Great Smoky Mountains National Park is more than a humane attempt to restore nature's balance lost over the years.[6] It is a belated effort to repair some of what we have destroyed in our world and therefore in ourselves, in our identity as Americans.

No one has stated this idea as forcefully as Wallace Stegner, the writer and environmentalist. In his "Wilderness Letter," presented to a congressional subcommittee in 1960, Stegner proclaimed, "We need wilderness preserved—as much of it as is still left, and as many kinds—because it was the challenge against which our character as a people was formed." He added that the reassurance that wilderness is preserved is good for our spiritual health "even if we never once in ten years set foot in it." When we are young, it can bring us "incomparable sanity" as vacation and rest. When we are old, wilderness is important "simply because it is there—important, that is, simply as idea."[7]

Carolyn Mason feels intuitively what Stegner wrote so eloquently. "When I'm on Shackleford with those horses," she says, "it gives me a whole new perspective on this universe, and our place in it. Seeing the horses gives you a taste of the freedom we don't have."[8] Or as Jamie Gillikin-Hibbs says of her young stallion, "Leo's good therapy for me!"[9] And that is exactly the point. Shackleford's horses—both wild and domesticated—are good therapy for us all as Americans increasingly locked in what Stegner called our technological "termite-lives." Even if their "wildness" is merely a mental construct or metaphor, the horses have an allure that is irresistible, for reasons we dimly comprehend.[10] Clearly, we need the horses on Shackleford Banks. With careful management, and by mandate of the United States Congress, it is reasonable to hope that Banker horses will continue there for many years, living out their lives—and enriching ours—in harmony with their Shackleford habitat.

Carolyn Mason and Sue Stuska on Shackleford Banks

ACKNOWLEDGMENTS

he Wild Horses of Shackleford Banks could not have been produced without the assistance of many people and organizations.

I am grateful to the English Department and the College of Humanities and Social Sciences at North Carolina State University for providing funds and research time. Staff members of the Core Sound Waterfowl Museum and Heritage Center, Perkins Library at Duke University, the North Carolina Collection at the University of North Carolina at Chapel Hill, the North Carolina Office of Archives and History, and the Rare Book Department of the New York Public Library located books and photographs of historical importance.

Others who were generous with their time and knowledge include Dr. Gus Cothran, Stephanie Dashiell, Chuck Edelman, Jerry Hyatt, Dr. Chuck Issel, Congressman Walter B. Jones, Jr., Dr. Jay Kirkpatrick, Joy Lawrence, Richard Meissner, John Prioli, Emma Dee Rose, Dr. Dan Rubenstein, Lynn Setzer, Cecil Tuten, and Sonny Williamson. Jamie Gillikin-Hibbs (with Leo), Penny Wright (with Sam), Susan Goines (with Angel), and Paul and Le Ann Henry (with Heloise) agreed to be interviewed and photographed with their adopted horses. At John F. Blair, Publisher, Carolyn Sakowski, Steve Kirk, and Debbie Hampton moved the book along smoothly at critical points in its development.

The support and confidence of the staff of Cape Lookout National Seashore and the board of directors of the Foundation for Shackleford Horses, Inc., were crucial to the production of this book. While many individuals from both of these organizations offered a wide variety of assistance, several deserve special recognition. Park Superintendents Karren Brown and Bob Vogel led the way to implementing the wild-horse preservation act and in the process bridged the gulf between the National Park Service and Down East citizens. Dr. Sue Stuska, Cape Lookout's wildlife

(horse) biologist, introduced me to the unfolding science and art of wild-horse management and offered technical advice on a wide range of topics. Park Ranger Karen Duggan generously shared her formidable knowledge of horse history. Margaret Wallace (formerly Margaret W. Willis) and Carolyn Mason were sources of information and encouragement from start to finish. They opened their doors, their records, and their hearts "for the horses."

Finally, I wish to thank Andrew Prioli, my son and fellow wrangler, for his companionship, his help, and his patience as we followed the horse trails of Shackleford Banks.

APPENDIX
ADOPTED HORSES/SHACKLEFORD HORSES AND FOALS IN THE CEDAR ISLAND HERD

ADOPTED HORSES

HORSE	BORN	ADOPTED	LOCATION
1. Agnes	1999	2001	Raleigh, N.C.
2. Alvin (Thunder)	2001	2003	Newport, N.C.
3. Anakin	1999	2001	Swansboro, N.C.
4. Angel	1999	2001	Swansboro, N.C.
5. Anita	2004	2005	Otway, N.C.
6. Berto	2004	2005	Straits, N.C.
7. Brazil	2002	2003	Elizabethton, Tenn.
8. Callie	2003	2005	Newport, N.C.
9. Captain (Peso)	2005	2006	Monticello, Fla.
10. Dakar	2002	2005	Pelletier, N.C.
11. Dasha	2001	2005	Straits, N.C.
12. Delores	2000	2001	Swansboro, N.C.
13. Denmark	2002	2003	Cedar Island, N.C.
14. Diablo	1998	2002	Hubert, N.C.
15. Diego	2004 (rescue)	2005	Coates, N.C.
16. Dinky	1999	2000	Otway, N.C.
17. Diplomat	1999	2001	New Bern, N.C.
18. Dominica	2002	2003	Newport, N.C.
19. Don Quixote	2004	2005	Efland, N.C.
20. Doron	2003	2005	Lowgap, N.C.

Horse	Born	Adopted	Location
21. Dublin (Lightning)	2002	2003	Newport, N.C.
22. Dumas	1998	2000	Panther Gap, N.C.
23. Dumlmop (Delilah)	1999	2000	Otway, N.C.
24. Dynamite (Pablo)	2005	2006	Monticello, Fla.
25. Haiti	2002	2003	New Bern, N.C.
26. Heloise	2000	2001	Swansboro, N.C.
27. Hershey	1999	2000	Hubert, N.C.
28. Hidalgo	2004	2005	Vass, N.C.
29. Holland	2002	2003	Otway, N.C.
30. Honduras	2002	2003	Elizabethton, Tenn.
31. Hugo	2004	2005	Dunnellon, Fla.
32. Jair	2003	2006	Bettie, N.C.
33. Jasper	2000	2002	Holly Springs, N.C.
34. Jersey	1999	2006	Bettie, N.C.
35. John Paul	1997	2000	Red Oak, N.C.
36. Leroy (Leo)	2000	2001	Newport, N.C.
37. Luis	2004	2005	Straits, N.C.
38. Luke	1998	2000	Pelletier, N.C.
39. Mabel	2000	2001	Virginia Beach, Va.
40. Sancho	2004	2005	Newport, N.C.
41. Scoogie	1999	2000	Rocky Mount, N.C.
42. Serena	2004	2005	Dunnellon, Fla.
43. Signet	1998	2000	Roxboro, N.C.
44. Smooth	2005	2006	Bettie, N.C.
45. Snail	2000	2001	Clinton, N.C.
46. Sophia	2000	2001	Bettie, N.C.
47. Sudan	2002 (rescue) 2004		Williston, N.C.
48. Tango	1996	2006	Bettie, N.C.
49. Thai	2002	2003	New Bern, N.C.
50. Tia	2004	2005	Efland, N.C.
51. Tibet (Spirit)	2002	2003	Bethel, N.C.
52. Togo (Cricket)	2002	2004	Swansboro, N.C.
53. Tristan	1999	2000	Wake Forest, N.C.
54. Triton (The Senator)	1999	2000	Straits, N.C.
55. Tupper	2000	2002	Oxford, Ga.
56. Wenzel	2003	2005	Lowgap, N.C.

SHACKLEFORD HORSES THAT HAVE JOINED
THE CEDAR ISLAND WILD HERD

HORSE	BORN	TRANSFERRED
1. Chief	1998	2003
2. Deliops	1998	2000
3. Dolby	1995	2001
4. Dorothy	1992	2001
5. Haven	1999	2003
6. Hoover	1999	2003
7. Kassie	1999	2003
8. Spade	1988	2003
9. Splish	1995	2001
10. Star	1990	2001

CEDAR ISLAND FOALS

FOAL	BORN	NAMED FOR	DAM
1. Jessie	2003	Jessie Goodwin	Dorothy (Shackleford herd)
2. Katherine	2003	Katherine Goodwin	Bucky (Cedar Island herd)
3. Perry	2002	Perry Goodwin	Star (Shackleford herd)
4. Poppa Al	2002	Alva James Goodwin	Coco (Cedar Island herd)
5. Ulva	2003	Ulva Styron	Splish (Shackleford herd)
6. Ronald	2002	Ronald Goodwin	Splish (Shackleford herd)
7. Worth	2002	Worth Harris	Dorothy (Shackleford herd)

NOTES

CHAPTER 1
"No one, except Marilyn, expected MissIsabell."

[1] David Stick, *The Outer Banks of North Carolina*, 311-12; Joel Hancock, *Strengthened by the Storm*, 11-13; Carmine Prioli, *Hope for a Good Season*, 10-12. "Ca'e Banks" is a local contraction for the area encompassing Cape Lookout, Core Banks, and Shackleford Banks. Ca'e Banker families are residents of the area who trace their lineage to colonial and 19th-century settlements on the Banks.

[2] Prior to the 1930s, the Outer Banks were excluded from North Carolina livestock laws, which required the fencing of grazing animals everywhere on the mainland.

[3] Tucker R. Littleton, "Strange Pasture," 12.

[4] Alton Ballance, *Ocracokers*, 175-76; Bob Brooks, "Riders of the Beach," 24-25, 69. Specifically, the North Carolina legislation states in part, "From and after July 1, 1958, it shall be unlawful for any person, firm or corporation to allow his or its horses, cattle, goats, sheep or hogs to run free or at large along the outer banks of this State. This Act shall not apply to horses known as marsh ponies or banks ponies on Ocracoke Island, Hyde County. This Act shall not apply to horses known as marsh ponies or banks ponies on Shackelford [*sic*] Banks between Beaufort Inlet and Barden's Inlet in Carteret County. [It excepts] those animals known as 'banker ponies' on the Island of Ocracoke owned by the Boy Scouts and not exceeding 35 in number" (*North Carolina Session Laws and Resolutions*, 1957, H.B. 336, chapter 1057).

[5] Various news reports.

[6] See http://www.frf.usace.army.mil/isabel/isabel.shtml and http://www.noaanews.noaa.gov/stories/s2091.htm.

[7] Stick, *The Outer Banks of North Carolina*, 184-94; Hancock, *Strengthened by the Storm*, 10-11.

[8] Sue Stuska to Carmine Prioli, July 13, 2005.

[9] John Alexander and James Lazell, *Ribbon of Sand*, 92.

[10] In an extensive study of the effects of ungulate grazing on the ecology of Shackleford Banks published in 1987, researchers noted, "The existence of an obvious browse-line along the edge of the forest suggested that foraging by sheep and goats was impeding, if not preventing, the spatial increase of maritime forest cover." See Gene W. Wood et al., "Ecological Importance of Feral Ungulates," 243.

[11] Stuska to Prioli, July 13, 2005.

CHAPTER 2
"The ancestors of Jennifer, Jupiter, and the rest were war horses."

[1] *The Wild Horses of Shackleford*, Discovery Channel.

[2] Stuska to Prioli, July 13, 2005.

Chapter 3
"The Land of Ayllón . . . He died here of disease."

[1] Deb Bennet, *Conquerors*, 193.

[2] Quoted in John J. Johnson, "The Introduction of the Horse into the Western Hemisphere," 599.

[3] Ibid.

[4] Paul E. Hoffman, *A New Andalusia and a Way to the Orient*, 4.

[5] Ibid., 315-28.

[6] Peter Martyr de Anghera, *De Orbo Novo*, vol. 2, 259.

[7] Ibid.

[8] Hoffman argues convincingly for a southerly location somewhere on Sapelo Sound in Georgia, where they established the town of San Miguel de Gualdape. Hoffman, *A New Andalusia and a Way to the Orient*, 68-73, 127-28; see also Clifford M. Lewis and Albert J. Loomie, *The Spanish Jesuit Mission in Virginia*, 7, n. 11.

[9] Quoted in Hoffman, *A New Andalusia and a Way to the Orient*, 86.

[10] Jeannetta O. Henning, *Conquistadores' Legacy*.

[11] Lewis and Loomie, *The Spanish Jesuit Mission in Virginia*, 13.

[12] The difficulty in transporting livestock, especially horses, across the ocean is indicated in the accounts of later chroniclers, who reported that losses of 25 to 50 percent were common. See Johnson, "The Introduction of the Horse into the Western Hemisphere," 598. Navigating the vast ocean with inexperienced pilots in ships poorly equipped for the transfer of livestock posed special challenges to those who saw the need for horses in the New World. Turbulent weather or a navigational error of just a few degrees could place a vessel south of the trade winds in the belt of calms, where the ship's crew might wait days or weeks for a wind to steer them back on course. Meanwhile, the on-board water supply would become depleted. To conserve enough for the survival of crew and passengers, horses were jettisoned overboard. Popular belief is that this is how the horse latitudes received their name.

CHAPTER 4
"Besides this Island, there are many [others] . . . replenished with Deere,
Conies, Hares and divers beastes."

[1] Over the years, Hakluyt's book and excerpts from it have often been reprinted, under a variety of titles. The exact title of the first edition (1589) is *The principall navigations, voiages and discoveries of the English nation*. Although published as a single unit, the book was divided into three "volumes." Due to its popularity and the availability of additional material, Hakluyt brought out a second edition under the title *The principal navigations, voyages traffiques & discov-*

eries of the English nation. Although this edition is typically listed as having three volumes, it actually came out in two parts. Volumes 1 and 2 were published as a single unit in 1598; volume 3 appeared in 1600.

2 David Beers Quinn, ed., *The Roanoke Voyages*, vol. 1, 92. For other references to this document, see also Arthur Barlowe, "The first voyage made to the coastes of America," in Richard Hakluyt, *The Principall Navigations* (London: G. Bishop and R. Newberie, 1589), 728, and David Beers Quinn and Raleigh Ashlin Skelton, eds., *The Principall Navigations* (photo-lithographic facsimile of 1589 edition, Cambridge: Cambridge University Press, 1965).

3 Quinn, ed., *The Roanoke Voyages*, vol. 1, 96, 105, 115.

4 Ibid., 96, n. 6.

5 Hawks does not include a bibliography, but his reference to "Hakluyt, vol. 3, p. 246" indicates that he was using the second edition of *The Principal Navigations* (1600). See Francis L. Hawks, *History of North Carolina*, vol. 1, 69.

6 Hawks, *History of North Carolina*, vol. 1, 88.

7 For a fuller treatment of Hawks's mistake, see Carmine Prioli, "What Did Captain Barlowe See: Horses or Hares?" *Roanoke Colonies Research Newsletter,* vol. 9 (2006), 3-4.

8 Quinn, ed., *The Roanoke Voyages*, vol. 1, 121, 159.

9 Ibid., 82.

10 Helen Hill Miller, *Passage to America*, 70; see also Karen Ordahl Kupperman, *Roanoke: The Abandoned Colony*, 37-38.

11 Quinn, ed., *The Roanoke Voyages*, vol. 1, 187.

12 Ibid., 176-77.

13 Ibid., 219.

14 Edmund S. Morgan, *American Slavery, American Freedom*, 39-40.

[15] Quinn, ed., *The Roanoke Voyages*, vol. 1, 208.

[16] Kupperman, *Roanoke: The Abandoned Colony*, 76.

[17] Quinn, ed., *The Roanoke Voyages*, vol. 1., 267, 357.

[18] Ibid., 283.

[19] See also Bonnie S. Urquhart, *Hoofprints in the Sand*, 66-67.

[20] Ivor Noel Hume, *The Virginia Adventure*, 5; Kupperman, *Roanoke: The Abandoned Colony*, 134.

[21] Thomas Hariot, *A Briefe and True Report of the New Found Land of Virginia*, 19.

[22] Quinn, ed., *The Roanoke Voyages*, vol. 1, 471.

CHAPTER 5
"Their corne began to wither by reason of a drouth."

[1] In his narrative, White recorded Fernandez's excuse that the individual he had previously traded with was murdered. Why this bit of information—if it was true—was earlier withheld from White is a mystery. White apparently took this duplicity as one of many indications that Fernandez's intention was to sabotage the venture. David Beers Quinn, ed., *The Roanoke Voyages*, vol. 2, 521; Lee Miller, *Roanoke: Solving the Mystery of the Lost Colony*, 69-70.

[2] Quinn, ed., *The Roanoke Voyages*, vol. 2, 524.

[3] Hariot, *A Briefe and True Report*, 27-28.

[4] David W. Stahle et al., "The Lost Colony and Jamestown Droughts," 564.

[5] Ibid., 566.

[6] Lewis and Loomie, *The Spanish Jesuit Mission in Virginia*, 39, n. 91.

[7] Quinn, ed., *The Roanoke Voyages*, vol. 2, 533.

[8] Searches for remains of the Roanoke settlers began when John Smith ranged out of Jamestown in 1607. Legions of amateur and professional archaeologists have followed in his footsteps up to the present time, but no one has been able to prove conclusively that any of the individuals who sailed with John White to the New World survived beyond 1587. Many theories have been devised regarding the fate of the "Lost Colony" at Roanoke, including the following: The colonists went north to the Chesapeake, their original destination, where eventually nearly all were killed by natives; they were absorbed by native tribes on the mainland; some of them went south to Croatoan, the place whose name was carved into the post that White found at Roanoke when he returned in 1590. Wherever the settlers may have gone, the fact remains that they vanished without a trace.

[9] Quinn, ed., *The Roanoke Voyages*, vol. 2, 611.

[10] Quoted in William Bradford, *Of Plymouth Plantation*, 214, n. 5.

[11] Hume, *The Virginia Adventure*, 240. The arrival of these horses must have been of some comfort to John Smith, the colony's beleaguered military commander. Smith had won distinction years earlier as a cavalryman fighting the Turks for the Roman emperor. In an image prophetic of the American frontier hero, he was depicted in a 1624 engraving firing a pistol from a rearing stallion. See Smith's portrait in John Smith, *The Complete Works of Captain John Smith*, vol.2, [394-95].

[12] "A Declaration of the State of the Colonie and Affaires in Virginia . . . ," *Virtual Jamestown*, http://www.virtualjamestown.org, Page 15.

[13] Ibid., Page 5.

[14] Robert Beverly, *The History and Present State of Virginia*, 312.

[15] Stick, *The Outer Banks of North Carolina*, 22, 266.

[16] Littleton, "Strange Pasture," 10.

[17] The other community was the village of Ocracoke, just across the inlet from Portsmouth. Stick, *The Outer Banks of North Carolina*, 43.

[18] Quoted in Stick, *The Outer Banks of North Carolina*, 82.

[19] Edmund Ruffin, *Agricultural, Geological, and Descriptive Sketches of Lower North Carolina and the Similar Adjacent Lands*, part 2, 130-31.

[20] Those sites are Shackleford Banks, where the horses are managed jointly by Cape Lookout National Seashore and the Foundation for Shackleford Horses, Inc.; Ocracoke, where the horses are fenced in and are managed by Cape Hatteras National Seashore; and Corolla, where a small herd lives in semi-feral conditions and is cared for by the Corolla Wild Horse Fund. Other herds representing a mixed variety of Banker and domestic horses exist in Assateague Island Seashore and Chincoteague in Virginia and Carrot Island and Cedar Island in North Carolina.

[21] Deb Bennet, in her compendious book, *Conquerors: The Roots of New World Horsemanship*, notes the effects of years of colonial crossbreeding among domestic and wild horses: "That the background of the horses early produced in the Old South was indeed various is confirmed by diverse reports. During 1614, Captain Samuel Argall presented the Virginians with a deckload of Norman (Breton) horses that had been taken in the sack of Port Royal and Acadia in Canada. There is also reference in the correspondence of seventeenth-century southern planters to the use of Scottish Galloways or Galweys (another ambling ox-headed relative of the Spanish, Breton, Welsh, and Hobby . . .) as saddle horses. Before 1690, the feral English, French, and Irish-breds were intermixing with Spanish jennets escaped from St. Augustine and the chain of Franciscan missions stretching northward through the Carolinas. The hybrid product of this meeting quickly entrenched itself in the Appalachian highlands of the western Carolinas and Georgia." Bennett, *Conquerors*, 346.

CHAPTER 6
"They were the horses we rode as children, and the horses our children rode."

[1] Stick, *The Outer Banks of North Carolina*, 32-33.

[2] David Stick speculates that the naming of Diamond City occurred in 1885. Stick, *The Outer Banks of North Carolina*, 188-89; Hancock, *Strengthened by the Storm*, 7-13.

[3] In 1726, the Lords Proprietors successfully recruited four Yankee whalers to the area. Samuel, Ephraim, and Ebenezer Chadwick and John Burnap—all "late of New England, now of Carteret Precinct"—are identified in county records licensing Samuel "with three boats to fish for whale or other Royal fish on the Seay Coast of this government." Quoted in Mrs. Fred Hill, *Historic Carteret County, North Carolina*, 21.

[4] Quoted in Jay Barnes, *North Carolina's Hurricane History*, 53. See also 197. The storm was named for the Puerto Rican village of San Ciriaco, where it killed hundreds of people.

[5] Barnes, *North Carolina's Hurricane History*, 52.

[6] Hancock, *Strengthened by the Storm*, 13.

[7] Susan Yeomans Guthrie, "Shackleford Banks," in Harkers Island United Methodist Women, *Island Born and Bred*, 285.

[8] David Yeomans, "The Harkers Island Fishermen," 7.

[9] Josiah Bailey, "A Way-of-Life Lost . . . ," in Harkers Island United Methodist Women, *Island Born and Bred*, 11.

[10] Fred Olds, in *Carteret County Heritage*, vol. 2, 413.

[11] Melville Chater, "Motor-Coaching through North Carolina," 476, 479.

[12] Cecil Tuten interview by Margaret W. Willis, September 2, 2002.

[13] Chater, "Motor-Coaching through North Carolina," 482.

[14] Brooks, "Riders of the Beach," 24.

[15] Ballance, *Ocracokers*, 175-77.

[16] http://www.nps.gov/caha/oc_ponies.htm.

[17] Dallas R. Willis interview by Margaret W. Willis, December 30, 1999.

[18] Wilson Davis died in 2004. A local businessman, he owned Banker horses and a West Virginia thoroughbred racing stable. He was also a charter member of the executive board of the Foundation for Shackleford Horses, Inc. His statement was recalled by Carolyn Mason and presented in an exhibit, "Wild Horses of Shackleford Banks," on display at the North Carolina Maritime Museum in Beaufort, North Carolina, in 2004.

[19] Harkers Island United Methodist Women, *Island Born and Bred*, 284.

[20] Dallas R. Willis interview by Margaret W. Willis, December 30, 1999.

[21] Joel G. Hancock to Carmine Prioli, November 13, 2002.

CHAPTER 7
"My personal opinion is that this . . . can be a management problem for us."

[1] "Seashore Bill Is Signed," *Raleigh News & Observer*, March 11, 1966.

[2] For a fuller discussion of the controversies associated with the establishment of the park, see Carmine Prioli, "The Stormy Birth of Cape Lookout National Seashore," in Candy Beal and Carmine Prioli, eds., *Life at the Edge of the Sea*, vol. 1, 125-45.

[3] While Core Banks is today managed as a "protected" area, which allows for some man-made structures and limited motor vehicle access, Shackleford Banks is currently designated (and is likely to remain) "proposed wilderness." As such, it is managed as wilderness.

[4] Cape Lookout National Seashore, *Park Management History*, microfilm reel #1.

[5] Wood et al., "Ecological Importance of Feral Ungulates," 243.

[6] Cape Lookout National Seashore, *Statement for Management*, 13.

[7] Cape Lookout National Seashore, *Management Plan for the Feral Horse Herd on Shackleford Banks*, 1.

[8] Sarah Friday Peters, "A Haven for Horses," 4.

[9] Cape Lookout National Seashore, *Environmental Assessment*, 1.

[10] Ibid., 8.

[11] Ibid., 1.

[12] "Shackleford's free spirits" (editorial), *Raleigh News & Observer*, September 24, 1995.

[13] "Pony plan is reasonable" (editorial), *Carteret County News-Times*, March 13, 1996.

[14] Cape Lookout National Seashore, *Environmental Assessment*, 14.

[15] Unlike the roundups that for years were conducted (on foot) by locals as part of their Fourth of July holiday, this first roundup was highly organized and mechanized. On November 12, mounted wranglers with border collies, all-terrain vehicles, and a spotter plane rounded up and corralled the horses. In the process, two animals were injured and had to be euthanized.

[16] Charles J. Issel, the Dwight-Markey professor of equine infectious diseases at the University of Kentucky, notes that most foals "do not contract EIA in utero, although the risk increases if acute disease occurs early during pregnancy. Foals alongside their infected dams are at lower risk than adults in the same pasture, either because vectors do not perceive them or passive antibody gives them some protection." Issel to Sue Stuska, September 8, 2005.

[17] Sue Stuska, "Coggins Test—Why?" 26.

[18] Among the locales considered was a farm in Florida specifically dedicated to caring for EIA-infected horses. However, the foundation quickly learned just how complicated it would be to transport infected horses across state lines. Authorization would have to be given by each state, and the horses would have to be shipped in sealed vans. Such transport would have been stressful even for domesticated horses used to highway travel. Movement in such enclosures over hundreds of miles may have severely traumatized feral horses unaccustomed to confined spaces.

[19] The North Carolina Horse Council (NCHC) is a group whose purpose is "to represent and further the common interest of the entire equine industry to North Carolina." Its brochure and Web site describe it as "the Voice of the North Carolina Horse Industry." The council asserts that the annual value of the horse industry to the state is more than half a billion dollars. Another statement, published jointly by the NCHC and the College of Agriculture and Life Sciences at North Carolina State University, reckons "the total annual monetary clout of the [horse] industry in N.C. at $704.4 million." See *Horses: A $704 Million Purse for North Carolina*.

[20] The procedure uses three drugs—xylazine hydorochloride (a tranquilizer), succinylcholine hydrochloride (which paralyzes the respiratory muscles), and pentobarbitol (a sedative).

[21] Editorial, *Carteret County News-Times*, November 20, 1996.

[22] Prioli, "The Stormy Birth of Cape Lookout National Seashore," 143-44. Although two rewards were offered for information leading to the conviction of anyone responsible for the headquarters' destruction, no one has ever come forward, nor has anyone ever been charged for the arson.

CHAPTER 8
"We do not want Congress telling us we must manage the horses."

[1] No one is certain what caused the deaths of Spirit and the mare. However, it appears likely that they died from a blockage of their digestive systems caused by feed that had been provided for them by well-intentioned but misguided individuals. Although domesticated Shackleford horses do quite well on processed feed, they must be introduced to it gradually.

[2] Walter B. Jones, Jr., interview by Carmine Prioli, February 20, 2003. Subsequent quotations of Congressman Jones are from this interview.

[3] Unless otherwise identified, this and all subsequent quotations of Finnerty and others appear in the *Congressional Record*.

[4] "Park service opposes bill to aid horses," *Raleigh News & Observer*, April 2, 1997; "Tests show little Spanish in banker ponies," *Carteret County News-Times*, September 21, 1997.

[5] *Congressional Record*, April 10, 1997.

[6] Cape Lookout National Seashore, *Park Management History*, microfilm reel #1, October 26, 1983.

[7] Jay F. Kirkpatrick to Carolyn Mason, August 4, 1996.

[8] http://www.shacklefordhorses.org.

[9] James B. Hunt, Jr., to Walter B. Jones, Jr., April 8, 1997.

[10] "Rally for the Horses," *Carteret County News-Times*, March 22, 1996; Jerry Hyatt interview by Carmine Prioli, June 16, 2004.

[11] "Fret not, Shackleford Ponies" (editorial), *Carteret County News-Times*, October 5, 1997.

[12] Karren C. Brown to Carmine Prioli, January 22, 2002.

CHAPTER 9
"Their tenacity of existence is heroic."

[1] Thornton Chard, "Did the First Spanish Horses Landed in Florida and Carolina Leave Progeny?" 99.

[2] Susan Bratton et al., "Island Horses' Genetic Diversity Evaluated."

[3] Dirk Frankenberg, *The Nature of North Carolina's Southern Coast*, 120.

[4] Urquhart, *Hoofprints in the Sand*, 45.

[5] Margaret W. Willis to Donald E. Bixby, March 9, 1999.

[6] D. Phillip Sponenberg, "History, Blood Typing and 'Just Looking,' " 10.

[7] Ibid.

[8] Mary Ann Thompson, "Blood Testing for Spanish Markers," 7.

[9] Sponenberg, "History, Blood Typing and 'Just Looking,' " 11.

[10] E. Gus Cothran, "Genetic Analysis of the Schakleford [*sic*] Banks Feral Horse Herd," 4.

[11] Ibid., 5.

[12] Ibid., 6.

[13] Ibid.

[14] E. Gus Cothran to Sue Stuska, March 12, 2003.

[15] "Stalking the Wild Horses of Shackleford Banks," *Fayetteville Observer-Times*, June 27, 1982.

[16] Although the original legislation called for "100 free roaming horses," Public Law 105-229

was amended on December 1, 2005, to call for "not less than 110 free roaming horses, with a target population of between 120 and 130 free roaming horses." See Public Law 109-117. After several years of study, observation, analysis, and discussion, scientists, National Park Service personnel, and horse advocates agreed (and Congress subsequently concurred) that the size of the herd could be increased without undue risk to the ecology of Shackleford Banks.

[17] U.S. House Subcommittee on Public Lands, *Hearing before the Subcommittee on Public Lands . . . Ninety-Second Congress*, 48, 3.

[18] *Bailey v McLean*, 151-52, 158. When the judge's analogy was shared with Cape Lookout wildlife biologist Sue Stuska, she noted that in her observations of wild horses, "it's not that the newcomer did not help with the digging; it's that he is lower on the pecking order. If he were an alpha [dominant] stallion higher on the pecking order, he'd get the water all to himself regardless of who dug it out!" Stuska to Carmine Prioli, November 24, 2003.

[19] Alexander Kaszas to Walter B. Jones, Jr., March 20, 1997.

[20] Joel Bourne, "A Walk on the Wild Side," 13.

[21] Daniel I. Rubenstein to Carolyn Mason, November 22, 1995.

[22] Kim McElroy, *Heart Connections*, 9-11.

[23] See Jay F. Kirkpatrick, *Management of Wild Horses by Fertility Control*.

[24] Georgia H. De Stoppelaire et al., *USGS, NPS, and NASA Investigate Horse-Grazing Impacts on Assateague Dunes Using Airborne Lidar Surveys*; see also John Brock and Asbury Sallenger, *Airborne Topographic Lidar Mapping for Coastal Science and Resource Management*.

[25] Daniel I. Rubenstein, meeting notes by Carolyn Mason, October 29-30, 2002.

[26] Jay F. Kirkpatrick to Carmine Prioli, December 30, 2003.

[27] Ibid.

[28] Cape Lookout National Seashore press releases (findings reports), April 30, 2003, and March 31, 2004. The 2004 report indicated that PZP inoculations on Shackleford have been 98 percent effective.

[29] Cape Lookout National Seashore, *Management Plan for the Feral Horse Herd on Shackleford Banks* (1999), 9-10. Specifically, the plan calls for the application of the following parameters:

1. To maintain genetic diversity, approximately 65 horses of breeding age will remain on Shackleford Banks. Youngsters will make up the remainder of the 100 to 110 [now 120 to 130] horses provided for.

2. Individuals that have not had the opportunity to reproduce will not be removed unless their genetic resources are otherwise reasonably represented (siblings, etc.).

3. The last female representative of a matrilineage will not be removed, nor will she be given immunocontraceptives.

4. The last breeding individual known to possess a particular genetic factor or blood-group combination will not be removed, nor will their [*sic*] ability to reproduce be restricted.

5. Removal of herd sires (alpha males) or lead mares (alpha females) will likely be disruptive. They will be removed only if recommended by genetics and behavioral experts.

CHAPTER 10
"Leo's good therapy for me!"

[1] On November 8, 2001, in part for its efforts in helping to manage the wild horses, the foundation received a Governor's Award for outstanding volunteer service "to the People and the State of North Carolina." And on March 22, 2003, the North Carolina Folklore Society presented the foundation with its annual Community Traditions Award.

[2] Jamie Gillikin-Hibbs interview by Carmine Prioli, September 2, 2002.

[3] Penny Wright interview by Carmine Prioli, September 3, 2002.

[4] Paul Henry and Le Ann Henry interview by Carmine Prioli, September 3, 2002.

[5] Susan Goines interview by Carmine Prioli, September 3, 2002.

[6] Loggerhead turtles are now among the legions of wild animals beaming their locations to scientists. See Katie Mosher, "N.C. Turtle Data Adding to Global Census."

[7] Wallace Stegner, *The Sound of Mountain Water*, 147.

[8] Carolyn Mason interview by Carmine Prioli, January 27, 2002.

[9] Gillikin-Hibbs interview by Prioli, September 2, 2002.

[10] For an excellent discussion of the "wildness" of the wild horse as metaphor, see Verlyn Klinkenborg, "The Mustang Myth."

SOURCES

Copies of unpublished reports, management plans, publications that would be difficult for readers to locate, correspondence, interview notes, some tapes, and other materials are on file in the Cape Lookout National Seashore archives, located at 131 Charles Street, Harkers Island, North Carolina.

BOOKS AND ARTICLES

Abbas, D. K. "Horses and Heroes: The Myth of the Importance of the Horse to the Conquest of the Indies." *Terra Incognitae* 18 (1986): 21-41.

Alexander, John, and James Lazell. *Ribbon of Sand: The Amazing Convergence of the Ocean and the Outer Banks*. Chapel Hill, N.C.: Algonquin Books, 1992.

Anghera, Peter Martyr de. *De Orbo Novo: The Eight Decades of Peter Martyr D'Anghera*. Translated by Francis Augustus MacNutt. 2 vols. New York and London: G. P. Putnam's Sons, 1912.

Ballance, Alton. *Ocracokers*. Chapel Hill and London: University of North Carolina Press, 1989.

Barnes, Jay. *North Carolina's Hurricane History*. Chapel Hill: University of North Carolina Press, 2001.

Bennet, Deb. *Conquerors: The Roots of New World Horsemanship*. Solvang, Calif.: Amigo Publications, 1998.

Beverly, Robert. *The History and Present State of Virginia*. Edited by Louis B. Wright. Chapel Hill: University of North Carolina Press, 1947.

Bourne, Joel. "A Walk on the Wild Side." *Maritimes Magazine* (August 20, 1987).

Bradford, William. *Of Plymouth Plantation: 1620-1647*. Edited by Samuel Eliot Morison. New York: Modern Library, 1952.

Bratton, Susan, Robin Goodloe, and Robert Warren. "Island Horses' Genetic Diversity Evaluated." *Park Science* 10, no. 3 (Summer 1990).

Brooks, Bob. "Riders of the Beach." *Boy's Life* (March 1956): 24-25, 69.

Chard, Thornton. "Did the First Spanish Horses Landed in Florida and Carolina Leave Progeny?" *American Anthropologist* 42 (1940): 90-106.

Chater, Melville. "Motor-Coaching through North Carolina." *National Geographic* 49, no. 5 (May 1926): 475-523.

Corbett, David Leroy. *Explorations, Descriptions, and Attempted Settlements of Carolina, 1584-1590*. Raleigh, N.C.: State Department of Archives and History, 1948 and 1953.

Day, Jean. *Banker Ponies: An Endangered Species*. Newport, N.C.: Golden Age Press, 1997.

Diamond, Jared. *Guns, Germs, and Steel: The Fates of Human Societies*. New York and London: W. W. Norton & Co., 1999.

"Droughts Affected Both Roanoke and Jamestown." *Roanoke Colonies Research Newsletter* 5, no. 2 (May 1998): 1, 6.

Frankenberg, Dirk. *The Nature of North Carolina's Southern Coast*. Chapel Hill and London: University of North Carolina Press, 1997.

Haines, Francis. *Horses in America*. New York: Thomas Y. Crowell Co., 1971.

Hakluyt, Richard. *The Principall Navigations, Voiages and Discoveries of the English Nation*. 1589. Photo-lithographic facsimile, Cam-bridge, England: Cambridge University Press, 1965.

———. *The Third and Last Volume of the Voyages, Navigations, Traffiques, and Discoveries of the English Nation*. London: George Bishop, Ralph Newberie, and Robert Barker, 1600.

Hancock, Joel. *Strengthened by the Storm: The Coming of the Mormons to Harkers Island, North Carolina, 1897-1909*. Morehead City, N.C.: Campbell & Campbell, 1988.

Hariot, Thomas. *A briefe and true report of the new found land of Virginia*. 1590. Facsimile reprint, New York: Dover Publications, 1972.

Harkers Island United Methodist Women. *Island Born and Bred: A Collection of Harkers Island Food, Fun, Fact and Fiction*. New Bern, N.C.: Owen G. Dunn Co., 1988.

Hawks, Francis L. *History of North Carolina*. Vol. 1. Fayetteville, N.C.: E. J. Hale & Son, 1857.

Henning, Jeannetta O. *Conquistadores' Legacy: The Horses of Ocracoke*. Privately printed, 1985.

Hill, Mrs. Fred. *Historic Carteret County, North Carolina*. Beaufort, N.C.: Carteret Historical Research Association, 1975.

Hoffman, Paul E. *A New Andalusia and a Way to the Orient: The American Southeast During the Sixteenth Century*. Baton Rouge: Louisiana State University Press, 1990.

Hume, Ivor Noel. *The Virginia Adventure— Roanoke to James Towne: An Archaeological and Historical Odyssey*. New York: Alfred A. Knopf, 1994.

Johnson, John J. "The Introduction of the Horse into the Western Hemisphere." *His-

panic *American Historical Review* 23, no. 4 (November 1943): 587-610.

Kirkpatrick, Jay F. *Into the Wind: Wild Horses of North America.* Minocqua, Wis.: Northword Press, 1994.

Klinkenborg, Verlyn. "The Mustang Myth." *Audubon* 96, no.1 (January-February 1992): 35-43.

Kupperman, Karen Ordahl. *Roanoke: The Abandoned Colony.* Totowa, N.J.: Rowman and Allanheld Publishers, 1984.

Lewis, Clifford M., and Albert J. Loomie. *The Spanish Jesuit Mission in Virginia, 1570-1572.* Chapel Hill: University of North Carolina Press, 1953.

Littleton, Tucker R. "Strange Pasture." *The State* 47, no. 4 (September 1979): 10-13.

Lowery, Woodbury. *The Spanish Settlements in the United States.* 2 vols. New York: 1911.

McElroy, Kim. *Heart Connections: A Quarterly Journal* 5 (2001).

Miller, Helen Hill. *Passage to America: Raleigh's Colonists Take Ship for Roanoke.* Raleigh: North Carolina Department of Cultural Resources, 1983.

Miller, Lee. *Roanoke: Solving the Mystery of the Lost Colony.* New York: Penguin Books, 2002.

Morgan, Edmund S. *American Slavery, American Freedom: The Ordeal of Colonial Virginia.* New York: W. W. Norton & Co., 1975.

Mosher, Katie. "N.C. Turtle Data Adding to Global Census." *Coastwatch* (Early Summer 2004): 23-25.

[O'Connor, R. D. W.] "The First Voyage." *North Carolina History Leaflets.* Series 1, no. 1. [Boston: Old South Leaflets, 1898].

Olds, Fred. *Orphans Friend and Masonic Journal* 50, no. 12 (August 21, 1925). Reprinted in *Carteret County Heritage—North Carolina,* vol. 2, Winston Salem, N.C.: Hunter Publishing Co., 1984.

Ossorio y Vega, Manuel Alavarez. *Manejo real en que se propone loque deben saber los caballeros.* Madrid, Spain: 1769.

Peters, Sarah Friday. "A Haven for Horses: Horse Lore Steers Debate over Outer Banks Herds." *Coastwatch* (May-June 1994): 2-9.

Prioli, Carmine. *Hope for a Good Season: The Ca'e Bankers of Harkers Island.* Asheboro, N.C.: Down Home Press, 1998.

———. "The Stormy Birth of Cape Lookout National Seashore." In *Life at the Edge of the Sea: Essays on North Carolina's Coast and Coastal Culture,* edited by Candy Beal and Carmine Prioli. Vol. 1. Wilmington, N.C.: Coastal Carolina Press, 2002.

———. "What Did Captain Barlowe See: Horses or Hares?" *Roanoke Colonies Research Newsletter,* vol.9 (2006), 3-4.

Quinn, David Beers. *The Lost Colonists: Their Fortune and Probable Fate.* Raleigh, N.C.: Division of Archives and History, 1984.

Quinn, David Beers, ed. *The Roanoke Voyages: 1584-1590.* 2 vols. London: Hakluyt Society, 1955.

Quinn, David Beers, and Alison M. Quinn, eds. *The First Colonists: Documents on the Planting of the First English Settlements in North America, 1584-1590.* Raleigh: North Carolina Division of Archives and History, 1982.

Ruffin, Edmund. *Agricultural, Geological, and Descriptive Sketches of Lower North Carolina and the Similar Adjacent Lands*. Part 2. Raleigh, N.C.: Institution for the Deaf & Dumb & the Blind, 1861.

Smith, John. *The Complete Works of Captain John Smith: 1580-1631*. Vol. 2. Edited by Philip L. Barbour. Chapel Hill and London: University of North Carolina Press, 1986.

Sponenberg, D. Phillip. "History, Blood Typing and 'Just Looking': Evaluating Spanish Horses." *Spanish Mustang Registry* (1997): 8-11.

Stahle, David W., et al. "The Lost Colony and Jamestown Droughts." *Science* 280 (April 24, 1998): 564-67.

Stegner, Wallace. *The Sound of Mountain Water*. Garden City, N.Y.: Doubleday & Co., 1969.

Stick, David. *The Outer Banks of North Carolina: 1584-1958*. Chapel Hill: University of North Carolina Press, 1958.

Stuska, Sue. "Coggins Test—Why?" *Eclectic Horseman* no. 13 (September-October 2003): 26-27.

Thompson, Mary Ann. "Blood Testing for Spanish Markers." *Spanish Mustang Registry* (1997): 7.

Thoreau, Henry David. "Walking." In *Collected Essays and Poems*. New York: Library of America, 2001.

Urquhart, Bonnie S. *Hoofprints in the Sand: Wild Horses of the Atlantic Coast*. Lexington, Ky.: Eclipse Press, 2002.

Weber, David J. *The Spanish Frontier in North America*. New Haven, Conn.: Yale University Press, 1992.

Wood, Gene W., Michael T. Mengak, and Mark Murphy. "Ecological Importance of Feral Ungulates at Shackleford Banks, North Carolina." *American Midland Naturalist* 118, no. 2 (1987): 236-44.

Yeomans, David. "The Harkers Island Fishermen." *Mailboat* 2, no. 7.

NEWSPAPERS

Carteret County News-Times, 1996-97.
Fayetteville Observer-Times, 1982.
Raleigh News & Observer, 1938, 1966, 1997.

REPORTS, MANAGEMENT PLANS,
AND GOVERNMENT PUBLICATIONS

Bailey v McLain. 215 N.C. 150 (1939).

Brock, John, and Asbury Sallenger. *Airborne Topographic Lidar Mapping for Coastal Science and Resource Management*. USGS Open-File Report 01-46.

Cape Lookout National Seashore. *Environmental Assessment: Alternatives for Managing the Feral Horse Herd on Shackleford Banks*. Report, January 22, 1996.

————. "Finding of No Significant Impact on Environmental Assessment for Managing the Feral Horse Herd on Shackleford Banks, Cape Lookout National Seashore." Addendum to report of January 22, 1996. February 8, 1996.

―――――. *Horses of Shackleford Banks*. Flier, May 2002.

―――――. *Management Plan for the Feral Horse Herd on Shackleford Banks*. National Park Service, July 1999.

―――――. *Park Management History*. Microfilm reel #1.

―――――. *Statement for Management: Cape Lookout National Seashore*. Revised, July 1987.

―――――. *2003 Findings Report on the Shackleford Banks Horses*. Press release, April 30, 2003.

―――――. *2004 Findings Report on the Shackleford Banks Horses*. Press release, March 31, 2004.

Cothran, E. Gus. "Genetic Analysis of the Schakleford [*sic*] Banks Feral Horse Herd." Report, Department of Veterinary Science, University of Kentucky, 1997.

De Stoppelaire, Georgia H., et al. *USGS, NPS, and NASA Investigate Horse-Grazing Impacts on Assateague Dunes Using Airborne Lidar Surveys*. USGS Open-File Report 01-382, July 2001.

Horses: A $704 Million Purse for North Carolina. Brochure, College of Agriculture and Life Sciences, North Carolina State University, 2000.

Kirkpatrick, Jay F. *Management of Wild Horses by Fertility Control: The Assateague Experience*. Scientific monograph NPS/NRASIS/NRSM-92/26. U.S. Department of the Interior, National Park Service, 1995.

U.S. House Subcommittee on Public Lands. *Hearing before the Subcommittee on Public Lands . . . Ninety-Second Congress. H.R. 795, H.R. 5375 and Related Bills*. Serial no. 92-5. Washington: GPO, 1971.

Vogel, Robert A. "Cape Lookout Lighthouse Transfer Ceremony." Typescript of speech, June 14, 2003.

ZooMontana Science and Conservation Biology Program. *Wildlife Fertility Control: Fact & Fancy*. Brochure available from ZooMontana, Billings, Mont.

WEB SITES

"A Declaration of the State of the Colonie and Affaires in Virginia . . . " *Virtual Jamestown* (2000). http://www.virtualjamestown.org. Click on "First Hand Accounts and Letters" to access this document.

"Equine Infectious Anemia." *aphis.usda.gov* (2003). http://www.aphis.usda.gov/lpa/pubs/fsheet_faq_notice/fs_aheia.html.

"Fossil Horses in Cyberspace." *Florida Museum of Natural History*. http://www.flmnh.ufl.edu/vertpaleo/.

"Hurricane Isabel." *Wikipedia: The Free Encyclopedia* (2006). http://en.wikipedia.org/wiki/Hurricane_Isabel.

"Hurricane Isabel in Duck, N.C., Sept. 18, 2003." *CHL: Coastal and Hydraulics Laboratory*. http://www.frf.usace.army.mil/isabel/isabel.shtml.

"The Late Pleistocene Extinctions." *Illinois State Museum: The Midwestern United States 16,000 Years Ago*. http://www.museum.state.il.us/exhibits/larson/LP_extinction.html.

"Local Legacies: Celebrating Community

Roots." *Library of Congress: American Folklife Center* (2006). http://lcweb.loc.gov/bicentennial/propage/NC/nc-3_h_jones6.html.

Mason, Carolyn. "History on Hooves: The Horses of Shackleford Banks" (time line). *Wild Horses of Shackleford Banks* (2004-5). http://www.shacklefordhorses.org/timeline.htm.

"NOAA Aircraft Takes Dramatic Photos of North Carolina Coast after Hurricane Isabel Unleashed Her Fury." *National Oceanic & Atmospheric Administration: U.S. Department of Commerce.* http://www.noaanews.noaa.gov/stories/s2091.htm.

North Carolina Horse Council: The Voice of the North Carolina Horse Industry (2006). http://www.nchorsecouncil.com/.

"Ocracoke Ponies: The Wild Bankers of Ocracoke Island." *The National Park Service: Cape Hatteras National Seashore* (2003). http://www.nps.gov/caha/oc_ponies.htm.

Wild Horses of Shackleford Banks (2004-5). http://www.shacklefordhorses.org.

Yukon Berengia Interpretive Centre (2000). http://www.beringia.com/.

FILMS

The Shackleford Banks Wild Horses. Doug Raymond Productions, Inc. (for Foundation for Shackleford Horses, Inc.), 2005.

The Wild Horses of Shackleford. Discovery Channel, 1985.

CORRESPONDENCE

Bowling, Ann T., to Margaret W. Willis, December 8, 1996.

Brown, Karren C., to Carmine Prioli, January 22, 2002.

Cothran, E. Gus, to Sue Stuska, March 12, 2003.

Dashiell, Stephanie, to Carmine Prioli, October 19, 2002.

Hancock, Joel G., to Carmine Prioli, November 13, 2002.

Hunt, James B., Jr., to Walter B. Jones, Jr., April 8, 1997.

Issel, Chuck (Charles L.), to Sue Stuska, September 8, 2005.

Kaszas, Alexander, to Walter B. Jones, Jr., March 20, 1997.

Kirkpatrick, Jay F., to Carmine Prioli, December 30, 2003.

———, to Carolyn Mason, August 4, 1996.

Rubenstein, Daniel I., to Carmine Prioli, October 12, 2002.

———, to Carolyn Mason, November 22, 1995.

Stuska, Sue, to Carmine Prioli, November 24, 2003.

———, to Carmine Prioli, July 13, 2005.

Willis, Margaret W., to Donald E. Bixby, March 9, 1999.

INTERVIEWS

Cothran, E. Gus. Telephone interview by Carmine Prioli. September 21, 2003.

Gillikin-Hibbs, Jamie. Interview by Carmine Prioli. Swansboro, N.C., September 2, 2002.

Goines, Susan. Interview by Carmine Prioli. Swansboro, N.C., September 3, 2002.

Henry, Paul, and Le Ann Henry. Interview by Carmine Prioli. Cape Carteret, N.C., September 3, 2002.

Hyatt, Jerry. Interview by Carmine Prioli. Harkers Island, N.C., June 16, 2004.

Jones, Walter B., Jr. Interview by Carmine Prioli. Greenville, N.C., February 20, 2003.

Mason, Carolyn. Interview by Carmine Prioli. Beaufort, N.C., January 27, 2002.

Rubenstein, Daniel I. Meeting notes by Carolyn Mason. Morehead City, N.C., October 29-30, 2002.

Tuten, Cecil. Interview by Margaret W. Willis. Williston, N.C., September 2, 2002.

Willis, Dallas R. Interview by Margaret W. Willis. Sea Level, N.C., December 30, 1999.

Willis, Margaret W. Interview by Carmine Prioli. Gloucester, N.C., December 23, 2003.

Wright, Penny. Interview by Carmine Prioli. Swansboro, N.C., September 3, 2002.

INDEX

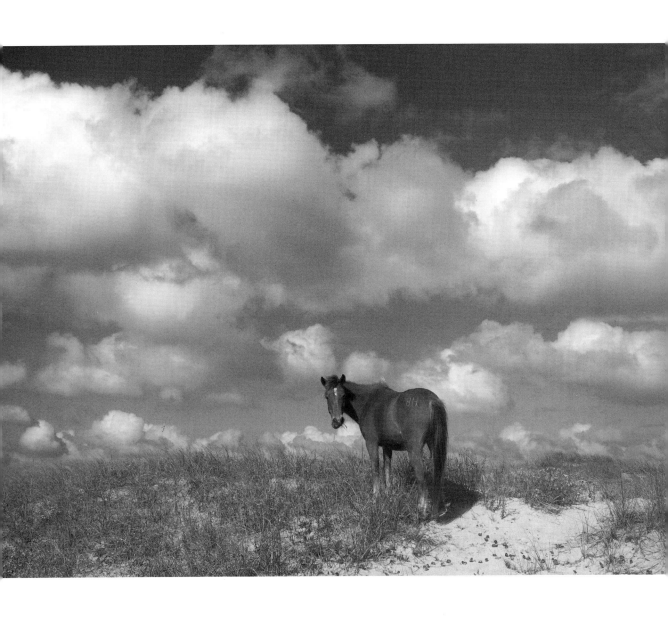

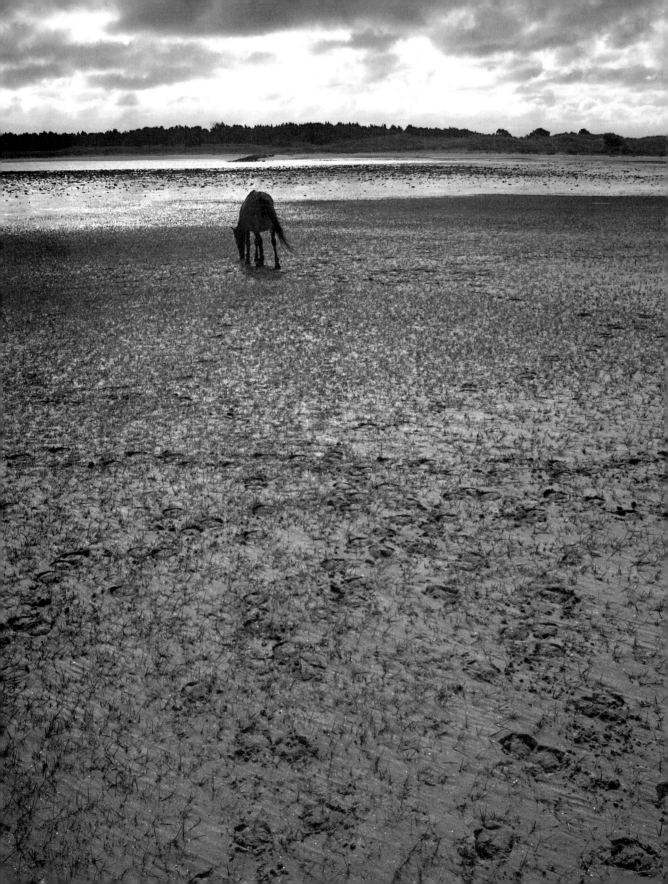